A Narrative on Calligraphy by Sun Guoting

Revised and Enhanced Edition

英譯書譜
增訂版

KS Vincent POON (潘君尚)
BSc, CMF, BEd, MSc

Kwok Kin POON (潘國鍵)
BA, DipEd, MA, MPhil, MEd, PhD

T0204312

The SenSeis

First Edition
March 2019

Published by
The SenSeis 尚尚齋
Toronto
Canada
www.thesenseis.com
publishing@thesenseis.com

ISBN 978-1-989485-10-1

In Loving Memory of Our Beloved

Pui Luen Nora TSANG（曾佩鑾）

1

永和九年歲在癸丑暮春之初會
于會稽山陰之蘭亭脩禊事
也羣賢畢至少長咸集此地
有峻領茂林脩竹又有清流激
湍暎帶左右引以為流觴曲水
列坐其次雖無絲竹管弦之
盛一觴一詠亦足以暢敘幽情
是日也天朗氣清惠風和暢仰
觀宇宙之大俯察品類之盛
所以遊目騁懷足以極視聽之
娛信可樂也夫人之相與俯仰

一世或取諸懷抱悟言一室之內
或因寄所託放浪形骸之外雖
趣舍萬殊靜躁不同當其欣
於所遇暫得於己快然自足不
知老之將至及其所之既惓情
隨事遷感慨係之矣向之所
欣俛仰之間以為陳迹猶不
能不以之興懷況脩短隨化終
期於盡古人云死生亦大矣
不痛哉每攬昔人興感之由
若合一契未嘗不臨文嗟悼不

A portion of KS Vincent Poon's model of Wang Xizhi's (王羲之)
Lanting Xu (蘭亭帖)
Semi-cursive script (行書)

Table of Contents

PART TWO:
Footnotes and Bibliography

PART THREE:
Modelling of *A Narrative on Calligraphy*

4

Introduction

(I)

A Narrative on Calligraphy (書譜, pronounced as Shu Pu) was written in 687AD by the renowned Tang dynasty calligrapher Sun Guoting (孫過庭, or Sun Qianli 孫虔禮) of the seventh century and is regarded to be one of the most important narratives in studying the art of Chinese calligraphy. The Chinese title, 書譜, is translated into English by others as *Treatise on Calligraphy* [i] or *Manual of Calligraphy* [ii], yet "Treatise" or "Manual" is far less accurate than "Narrative" in translating the word "譜" in this context, as both words do not bear the meaning of "recording and narrating". [iii]

The presumable original masterpiece of *A Narrative on Calligraphy* can be observed in the National Palace Museum, Taipei, Taiwan. However, whether this is a partial, complete, or simply the preamble of Sun Guoting's *A Narrative on Calligraphy* is still in question. [iv]

(II)

Aside from its aesthetic beauty, *A Narrative on Calligraphy* is an early document that analyzes and details the art of Chinese calligraphy in a relatively more systematic manner. Hence, its textual content is often considered to be an important resource for studying and understanding Chinese calligraphy. Drawing from traditional Chinese values and philosophies, Sun Guoting provided a narrative that outlined the aesthetics and techniques in calligraphy as well as his deliberation on the importance of one's temperaments/conducts in writing good calligraphy. Therefore, it

is a must-read for anyone who is interested in studying Chinese calligraphy or traditional Chinese culture.

(III)

This book is the revised edition of my 2018 book of the same title and delivers an even more precise translation with 20 titled thematic paragraphs that is based on Kwok Kin POON's *The Vernacular Chinese Translation of Sun Guoting's A Narrative on Calligraphy* (孫過庭書譜白話對譯. Toronto: The SenSeis, Feb. 2019).

This book has three parts. Part one is the annotated line-by-line English translation of the original text. Part two highlights the translation's explanatory footnotes that are written by referencing numerous historical texts; these footnotes not only include in-depth elaborations, but also illustrate the many fundamental misinterpretations made in the translations by Chang Ch'ung-ho & Hans H. Frankel[v] and Pietro De Laurentis[vi]. Finally, part three is a model (臨寫) of *A Narrative on Calligraphy* scribed by myself.

It is our sincere hope that this book can help readers to achieve a more in-depth, correct, and clear understanding of Sun Guoting's philosophies towards Chinese calligraphy.

KS Vincent POON
March 2019

i. Chang Ch'ung-ho & Hans H. Frankel, *Two Chinese Treatises on Calligraphy*. New Haven & London: Yale University Press, 1995.

ii. Pietro De Laurentis, *The Manual of Calligraphy by Sun Guoting of the Tang*. Napoli: Universita degli Studi di Napoli "L'Orientale", 2011.

iii. The word "譜" in *Kangxi Dictionary* (《康熙字典》) is defined as "籍錄也(to record and narrate)".

iv. 啟功〈孫過庭書譜考〉。《啟功叢稿》北京: 中華書局, 1999, pp.105-108。

v. Chang Ch'ung-ho & Hans H. Frankel, ibid.

vi. Pietro De Laurentis, ibid.

PART ONE:

English Translation of
A Narrative on Calligraphy (Shu Pu)

君諱全，字景完，敦煌效穀人也。其先蓋周之胄，武王秉乾之機，翦伐殷商，既定爾勳，福祿攸同，封弟叔振鐸于曹國，因氏焉。秦漢之際，曹參夾輔王室。世宗廓土斥竟，子孫遷于雝州之郊，分止右扶風，或在安定，或處武都，或居隴西，或家敦煌。枝葉分布，所在為雄。君高祖父敏，舉孝廉，武威長史，巴郡朐忍令，張掖居延都尉。曾祖父述，孝廉，謁者，金城長史，夏陽令，蜀郡西部都尉。祖父鳳，孝廉，張掖屬國都尉丞，右扶風隃麋侯相，金城西部都尉，北地太守。父琫，少貫名州郡，不幸早世，是以位不副德。君童齔好學，甄極瑌緯，無文不綜。賢孝之性，根生於心，收養季祖母，供事繼母，先意承志，存亡之敬，禮無遺闕。是以鄉人為之諺曰：重親致歡曹景完。易世載德，不隕其名。及其從政，清擬夷齊，直慕史魚，歷郡右職，上計掾史，仍辟涼州，常為治中，別駕紀綱，万里朱紫，不謬。出典諸郡，彈枉糾邪，貪暴洗心，同僚服德，遠近憚威。建寧二年，舉孝廉，除郎中，拜西域戊部司馬。時疏勒國王和德，弒父篡位，不供職貢。君興師征討，有兗膿之仁，分醪之惠，攻城野戰，謀若涌泉，威牟諸賁，和德面縛歸死。還師振旅，諸國禮遺，且二百萬，悉以簿官。遷右扶風槐里令，遭同產弟憂，棄官。續遇禁罔，潛隱家巷七年。光和六年，復舉孝廉。七年三月，除郎中，拜酒泉祿福長。訞賊張角，起兵幽冀，兗豫荊楊，同時並動。而縣民郭家等，復造逆亂，燔燒城寺，萬民騷擾，人褱不安，三郡告急，羽檄仍至。於是共府造詣，故吏王敞、王畢等，惤其民之要，存慰高年，撫育鰥寡。

A portion of KS Vincent Poon's model of
Cao Quan Stele (曹全碑)
Clerical script (隸書)

8

English Translation
of *A Narrative on Calligraphy (Shu Pu)*

by KS Vincent POON（潘君尚）

Paragraph 1: On the Four Meritorious Calligraphers of the Han and Jin dynasties as well as the nature of unadorned simplicity and refined elegance in the art of calligraphy

1. 夫自古之善書者，漢魏有鍾張之絕，晉末稱二王之妙。
Alas, since a long time ago, those who were regarded to have scribed great calligraphy[1] were Zhong (Zhong Yao 鍾繇, 152–230AD) and Zhang (Zhang Zhi 張芝, ?-192AD) of the Eastern Han to Wei Period (1st to 5th Century AD), both of whom produced unrivaled masterpieces, as well as the Two Wangs (Wang Xizhi 王羲之, 303–361AD ; and Wang Xianzhi 王獻之, 344–386AD) of the late Jin dynasty (265-420AD) who both produced wonderful works of exquisite beauty.

2. 王羲之云：「頃尋諸名書，鍾張信為絕倫，其餘不足觀。」
Wang Xizhi once said, "I have searched and reviewed various renowned works of calligraphy and concluded that only Zhong and Zhang's works are truly superior and unrivaled; works by others are unremarkable and so not even worth studying."[2]

3. 可謂鍾張云沒，而羲獻繼之。
Hence, it can be said that after the death of Zhong and Zhang, Xizhi and Xianzhi were the ones who had truly succeeded them.

9

4. 又云:「吾書比之鍾張,鍾當抗行,或謂過之。張草猶當鴈行,然張精熟, 池水盡墨, 假令寡人耽之若此,未必謝之。」

Wang Xizhi further commented, "If one were to compare my calligraphy with those scribed by Zhong (Yao) or Zhang(Zhi), my work is comparable to those written by Zhong, if not better. My cursive script may also be considered to be comparable to Zhang's[3]. Yet, Zhang was so refined in his art and so focused on the practice of calligraphy that even a pond could had been completely tainted by the ink washed from his brushes. If I could have the same degree of obsession in the art as Zhang's, perhaps my works may not be inferior to those of Zhang's."

5. 此乃推張邁鍾之意也。

This clearly demonstrates Wang Xizhi highly appreciated Zhang's calligraphic achievements while he believed his achievements had exceeded those of Zhong's.

6. 考其專擅, 雖未果於前規; 摭以兼通, 故無慙於即事。

As one scrutinizes Wang Xizhi's distinctive strengths in calligraphy, despite the fact that Wang Xizhi could not completely implement the rules established from the past, he had the ability to extract the features of past masterpieces and incorporated them into his calligraphy in additional to being adept at scribing various script styles. Hence, it can be said, with clear conscience, that he was not inferior (無慙) to Zhang Zhi and Zhong Yao in the issue (即事) of comparing his calligraphy with Zhang's and Zhong's.

7. 評者云:「彼之四賢,古今特絕。而今不逮古,古質而今妍。」

Various critics attested, "These Four Meritorious Calligraphers (四賢: Here, it refers to Zhong Yao, Zhang Zhi, Wang Xizhi and Wang Xianzhi) were indeed truly exceptional and

unmatched both in the past and present. Further, exemplary calligraphers of our times did not reach the same level achieved by those of the past; generally, past calligraphers produced works that were relatively simple and unadorned while calligraphers of the present created works that were relatively elegant and pretty."[4]

8. 夫質以代興,妍因俗易。

Alas, unembellished styles of simplicity can become fashionable at times[5], while elegant qualities of prettiness vary as customs change over time.

9. 雖書契之作,適以記言,

Although characters were originally created merely to serve the purpose of recording speeches and texts,

10. 而淳醨一遷, 質文三變。

the styles of calligraphy evolve dynamically with the progression of time: once trendy preferences shift between honest purity and light superficiality, changes in styles of unadorned simplicity together with refined elegance will, in turn, come frequently with many varieties[6].

11. 馳騖沿革, 物理常然。貴能古不乖時,今不同弊。

Swift, rapid and unrestrained (馳騖) reformations in the course of human history are certainly natural, in accordance with the Law (理) that governs all things. Yet, the most valuable reforms are the ones that account for the past simplicity but not unfashionable and, at the same time, fashionable yet stand out from the mundane vulgarity of the times.

12. 所謂「文質彬彬, 然後君子。」

As the old saying goes: "When the accomplishments and solid qualities (in this context, Sun Guoting was referring to the styles of refined elegance 文 and unadorned simplicity 質 correspondingly) are equally blended, we then have the man of virtue."[7]

13. 何必易雕宮於穴處, 反玉輅於椎輪者乎!

After all, there is no need to relinquish an extravagant palace to dwell in a barren cave or to abandon a luxurious royal carriage for a primitive wooden cart!

14. 又云:「子敬之不及逸少, 猶逸少之不及鍾張。」

Critics further asserted, " Zijing's (Wang Xianzhi's) artistry was inferior to those of Yishao's (Wang Xizhi's), just like Yishao's artistry was inferior to those of Zhong's (Zhong Yao's) and Zhang's (Zhang Zhi's)."

15. 意者以為評得其綱紀, 而未詳其始卒也。

While I think perhaps they might have pointed out the overall key aspects of the matter, they failed to detail the evolution of the entire issue.

16. 且元常專工於隸(隸)書, 百(白也，即伯)英尤精於草體;

Alas, Yuanchang (Zhong Yao) was skilled in scribing the standard script[8] while Boying (Zhang Zhi) was adept at scribing the cursive script;

17. 彼之二美, 而逸少兼之: 擬草則餘眞, 比眞則長草。

the beauties of their two artistries yet could also be seen in Yishao's (Wang Xizhi's) works[9]: relative to Zhang Zhi, Wang Xizhi wrote better standard script; comparing with Zhong Yao, Wang Xizhi wrote better cursive script.

18. 雖專工小劣, 而博涉多優。揔其終始, 匪無乖互。

Although Wang Xizhi paid less focus on one particular script, he nonetheless was knowledgable in a wide variety of exemplary styles of the past and was able to assimilate them into his calligraphy with excellent results. Hence, summing up the evolution of the entire matter, the assertions made by the critics are not without any mistake[10].

19. 謝安素善尺牘, 而輕子敬之書。

Xie An (謝安, 320-385AD) was known to be naturally adept at scribing *chi du* (尺牘, a short letter or memo, usually regarded as a calligraphic work), and he did not hold a high regard for Zijing's (Wang Xianzhi's) calligraphy.

20. 子敬嘗作佳書與之, 謂必存錄。

At one time, Zijing wrote a piece of calligraphy that he thought was good, gave it to Xie An, and thought that Xie An would treasure and retain it.

21. 安輒題後答之，甚以為恨。

An (Xie An), however, responded immediately[11] by returning the work to Zijing with his comments attached. Zijing was infuriated.

22. 安嘗問敬：「卿書何如右軍？」答云：「故當勝。」

An once asked Zijing, "How does your calligraphy compared to Youjun's (Wang Xizhi, father of Wang Xianzhi or Zijing)?" Zijing replied, "Of course I surpassed him."

23. 安云：「物論殊不爾。」子敬又答：「時人那得知！」

An said, "That is extremely contrary to comments made by others in the general public." Zijing replied, "What do ordinary contemporaries understand!?"

24. 敬雖權以此辭折安所鑒，自稱勝父，不亦過乎！？

Although Zi (Zijing) used this rebuttal to censure An's scrutiny, he nonetheless claimed he had surpassed his own father; isn't that already a moral mistake[(12)]!?

25. 且立身揚名，事資尊顯；

Indeed, conducting oneself properly in society and hence establishing one's fame are, fundamentally, relied upon honoring and glorifying one's parents[(13)];

26. 勝母之里，曾參不入。

[that is why] Zeng Shen (曾參, 503-435BC) did not enter a district named Sheng Mu (勝母, which means "surpassed one's own mother")[(14)].

27. 以子敬之豪翰，紹右軍之筆札，雖復粗傳楷則，實恐未克箕裘。

If one were to regard Zijing's penmanship as a succession of Youjun's calligraphy, although Zijing did roughly grasp his father's principles in the art, I am afraid he genuinely was unable to succeed his father's artistry.

28. 況乃假託神仙，恥崇家範，以斯成學，孰愈面墙！？

Moreover, he proclaimed the power of celestial beings as a pretext for his calligraphic skills[(15)] and had often expressed shame in honoring the calligraphic tenets established in his own family; with such an attitude towards perfecting his art in calligraphy, how can he accomplish more than a person who is "facing a wall (面墙)" (a wall that blocks one's vision and impedes one from learning beyond it)[(16)]!?

29. 後羲之往都，臨行題壁。子敬密拭除之，輒書易其處，私為不惡。

14

Afterwards, there was a time when Xizhi was leaving for the capital and, before his departure, scribed something on a wall. Zijing then surreptitiously scratched them out and replaced them immediately by transcribing the parts scribed by Xizhi with his own calligraphy, believing his works were not bad at all.

30. 羲之還見，乃歎曰：「吾去時真大醉也！」敬乃內慙。

When Xizhi later returned and saw them, Xizhi sighed and said, "I must have been extremely drunk when I left for the capital!" Zijing then felt ashamed of himself.

31. 是知逸少之比鍾張，則專博斯別；子敬之不及逸少，無或疑焉。

Thus, if one were to compare Yishao's (Wang Xizhi's) calligraphy with those of Zhong's (Zhong Yao's) and Zhang's (Zhang Zhi's), it is merely just a matter of differences between scope and depth (see lines 16, 17 and 18); while it is certain, without any doubt, that Zijing was inferior (with respect to artistry and moral character) to Yishao's.

Paragraph 2: On basic scribing techniques and their essential elements and properties

32. 余志學之年，留心翰墨。

At the age of fifteen[17], I began to pay a great deal of attention to the art of calligraphy.

33. 味鍾張之餘烈，挹羲獻之前規，極慮專精，時逾二紀。

I had researched on[18] the past great works by Zhong (Zhong Yao) and Zhang (Zhang Zhi), and took and followed[19] the past rules established by Xi and Xian (Wang Xizhi and Wang Xianzhi) with great deliberation and dedi-

cation for over twenty-four years[20].

34. 有乖入木之術，無間臨池之志。

Although I have not been completely loyal to the techniques that can grant one the ability to write outstanding calligraphy (入木)[21] (this should be read as a self-effacing statement by Sun Guoting), I nonetheless have kept my unintermitted determination in practicing the art throughout the years.

35. 觀夫懸針垂露之異，

Observing the many variety of brushstrokes displayed in calligraphy, there are some that are distinctive[22] like vertical hanging needles[23] or like the vertical paths of dews that are about to drop towards the ground[24],

36. 奔雷墜石之奇，

some can give one the fantastic perception of hearing roaring thunders or watching a free-falling boulder,

37. 鴻飛獸駭之資，

some resemble the inherent nature of unrestrained movements seen in the flights of magnificent geese or in the motions of startled beasts [25],

38. 鸞舞蛇驚之態，

some appear as if phoenixes are dancing or snakes are frightened,

39. 絕岸頹峰之勢，

some mimic the terrains of a precipitous cliff standing beside a shore or a steeply descending alp rising above the ground,

40. 臨危據槁之形。

some can give the impression that they are facing near-death or that they are already in a state of death, dried and withered[26].

41. 或重若崩雲，或輕如蟬翼。

At times, the resulting outline from the brush can be as heavy as thick clouds[27], or, at other times, as light as cicada's wings.

42. 導之則泉注，頓之則山安。

When the brush is directed to move, it flows as if it is a stream of water gushing out of fountains; when it stops, it appears to be anchored like an immovable mountain resting firmly on the ground.

43. 纖纖乎似初月之出天崖，落落乎猶眾星之列河漢。

The resulting brushstrokes can hence be as delicate and refined as if they were New Moons that have just risen over the horizon[28] or as widely scattered as the many stars dispersed throughout the Galaxy.[29]

44. 同自然之妙有，非力運之能成。

All exist due to the marvels of Mother Nature and cannot be created by mere human efforts alone.

45. 信可謂智巧兼優，心手雙暢。

Hence, the art is truly a culmination of intelligence and exemplary techniques, with both the mind and hands working smoothly together.

46. 翰不虛動，下必有由。

Every brush movement is not unnecessary and each

brushstroke is made with a reason.

47. 一畫之間，變起伏於峯杪；

Within a line, there are wave-like irregularities in thickness that are made by the varying use of the tip of a brush[30];

48. 一點之內，殊衄挫於毫芒。

within a dot, the Nu (衄) and Cuo (挫) techniques[31] are made discernible by the fine brush tip.

49. 況云積其點畫，乃成其字。

Moreover, it is said that the scribing of a character is based on the assemblage of lines and dots.

50. 曾不傍窺尺牘，俯習寸陰，

Thus, if one has not carefully studied *chi du* (in this context, it refers to the art of calligraphy) and does not cherish every moment to focus on learning the art,

51. 引班超以為辭，援項籍而自滿，

cites Ban Chao's (班超 32-102 AD) comment[32] as a rebuttal [against practicing the art of calligraphy] as well as possesses the type of arrogance seen in Xiang Ji (項籍, 232-202BC)[33],

52. 任筆為體，聚墨成形，

lets one's brush to arbitrarily form the bodies of characters on their own while allowing aggregates of ink blobs to aimlessly produce the shapes of characters without consideration,

53. 心昏擬效之方，手迷揮運之理，

scribes with a mind that does not understand the right

method to modelling exemplary works while the hand is at a loss in the proper ways to moving a brush,

54. 求其妍妙，不亦謬哉!?
wouldn't it be ridiculous to expect such an individual to seek the wonders of calligraphy!?

Paragraph 3: On the applications of the art of calligraphy

55. 然君子立身，務修其本。
Yet, for a gentleman to conduct himself properly in society, it is necessary for him to first refine and cultivate his own innate character.

56. 揚雄謂詩賦小道，壯夫不為，
Yang Xiong (揚雄 53BC -18BC) once said poetries and songs are trivial and minor arts, and hence a strong and able adult should not spend time practicing them,

57. 況復溺思豪釐，淪精翰墨者也。
let alone additionally be obsessed with penmanship (豪釐)[34] and losing oneself in dedication to the world of calligraphy.

58. 夫潛神對弈，猶標坐隱之名；
Alas, concentrating all one's efforts into playing chess is tantamount to establishing one's fine reputation as a Zuo Yin (坐隱, a classical Chinese term that is used to describe Go Chess 圍棋. The term carries an implication that players are expected to tranquilly sit 坐 and play while finding joy and serenity in being a recluse 隱);

59. 樂志垂綸，尚體行藏之趣。

and even taking pleasure in dedicating oneself to fishing in solitude (垂綸)[35] can allow one to experience the savors of being at peace with whatever the circumstances (行藏)[36].

60. 詎若功定禮樂，

Moreover, many do not realize that calligraphy (as a means to scribe) (詎若)[37] has the application of helping to revise the Rites and Music (禮樂)[38],

61. 妙擬神仙 。

and it is as marvelous as celestial beings.

62. 猶挺埴之罔窮，

It can have infinite variations (罔窮)[39] tantamount to the boundless changes created when a skilled potter is hand-kneading clays to make different potteries (挺埴)[40],

63. 與工鑪而並運。

and [is a wonder] that is akin to the exquisite metallic crafts made by blacksmiths that can stand the test of time. [41]

64. 好異尚奇之士，翫體勢之多方；

For those who appreciate the wonders and marvels of calligraphy, they often like to toy around scribing characters in different shapes and manners in many ways and directions;

65. 窮微測妙之夫，得推移之奧賾。

for those who like to examine the art of calligraphy in extreme detail, they will be able to obtain knowledge and understanding of the profound and subtle implications (奧賾)[42] hidden within the variations (推移)[43] observed in

calligraphy.

66. 著述者假其糟粕，藻鑒者挹其菁華。

Writers and critics often focus and rely (假) on the dregs of calligraphy (糟粕)[44] , but those who can truly appraise it will be able to extract and obtain (挹)[45] the essence of the art.

67. 固義理之會歸，信賢達之兼善者矣。

Hence, calligraphy is a culmination of the principles of righteousness (義理)[46], and so I believe those who are wise, talented and virtuous (賢達)[47] should be able to write good calligraphy as well.

68. 存精寓賞，豈徒然與!?

Therefore, if one were to devote oneself towards preserving the best in calligraphy for others to see and appreciate, how could such dedication be in vain!?

Paragraph 4: On the flaws commonly seen in learning calligraphy during the Eastern Jin and the Southern dynasties

69. 而東晉士人，互相陶染(淬?)。

Further, the gentries and intellects of the Eastern Jin dynasty (317-420AD) had influenced and cultivated each other amongst themselves [in the art of calligraphy].

70. 至於王、謝之族，郗、庾之倫，縱不盡其神奇，咸亦挹其風味。

In regard to the clans of Wang (王) and Xie (謝) as well as the likes of Xi (郗) and Yu (庾) [48], although they had not fully exhibited the wonders of calligraphy, they all none-

theless were able to pick up and attain the distinct artistic flavors cherished in the art.

71. 去之滋永，斯道逾微。

As time progresses further away from the Eastern Jin, however, the more decline we see in the art of calligraphy.

72. 方復聞疑稱疑，得末行末。

Additionally, calligraphers later began the practice of listening to dubious claims regarding the art and praised (稱)[49] them [without questioning]; and when they learned some trivial techniques (末)[50], they applied them passionately to their calligraphy [without scrutiny].

73. 古今阻絕，無所質問。

Eventually, the succession of the artistry from the past to present is blocked and insulated, and so no one is able to seriously ask any question in detail.

74. 設有所會，緘祕已深。

Even if one were to somehow come into realization of something profound and important, one would generally hide and conceal (緘)[51] it deeply within oneself and not share it with anyone.

75. 遂令學者茫然，莫知領要。

All these factors consequently cause learners to be at a loss and without truly knowing the essence of the art.

76. 徒見成功之美，不悟所致之由。

They can only see the beauties of the accomplished but fail to understand the reasons that bring about them.

77. 或乃就分布於累年，向規矩而猶遠。

Therefore, some have spent numerous years studying the layouts and structures [within and among characters of calligraphic works], but their works are still quite far from following the established rules in writing calligraphy.

78. 圖真不悟，習草將迷。

As they model (圖)[52] standard script, they cannot come to an understanding of it; when they practice cursive script, they are puzzled by it.

79. 假令薄解草書，粗傳隸(隸)法，則好溺偏固，自闕通規。

Even if one were to have a sketchy comprehension of the cursive script and a scant conveyance of the standard script (隸)[53], one would still nonetheless like to be indulged in their own stubbornly held prejudice, isolating and removing oneself (自闕)[54] from the established tenets of calligraphy (通規)[55].

80. 詎知心手會歸，若同源而異派；

Who knew that the art is actually a culmination of intelligence and dexterity like different water streams originating from one river source;

81. 轉用之術，猶共樹而分條者乎？

while the different techniques in turning and moving the brush are like wood branches growing out of the same tree?

Paragraph 5: On the various scripts in calligraphy

82. 加以趨變(?)適時，行書為要；

Also, for following changes with the times (趨變)[56] and

accommodating accordingly to such circumstances, scribing in semi-cursive script is more appropriate (為要)[57];

83. 題勒方畐，真乃居先。

for titling books (or documents) and inscribing steles that necessitate specific formats (題勒方畐)[58], scribing in standard script is most preferable.

84. 草不兼真，殆於專謹：

If one were to scribe cursive script without mastering the techniques in scribing the standard script, then the outcome would have the shortcoming of being too dull and monotonous;[59]

85. 真不通草，殊非翰札。

on the other hand, if one were to scribe standard script with no proficiency in scribing the cursive script, then the end result could not be considered as *han zha* (翰札, which refers to scribing letters with lively penmanship).[60]

86. 真以點畫為形質，使轉為情性：

Standard script relies on dots and strokes to define its physical form, while moving the brush (使)[61] and turning it in concert (轉)[62] give rise to its vitality, manner and aesthetic flavor (情性)[63];

87. 草以點畫為情性，使轉為形質。

by contrast, cursive script relies on dots and strokes to bring about its vitality, manner and aesthetic flavor, while moving the brush and turning it in concert determine its physical form.

88. 草乖使轉，不能成字；

Scribing cursive script without properly moving the brush and turning it in concert will result in not forming characters at all;

89. 真虧點畫，猶可記文。

while scribing standard script with imperfect dots and strokes can still serve to record texts.

90. 迴互雖殊，大體相涉。

Although the dynamics (迴互)[64] of scribing the brush-strokes of the two scripts are different, they are still more or less related to each other in their artistries.

91. 故亦傍通二篆，俯貫八分，

Consequently, one should also have a good knowledge and command of other areas, such as the two seal scripts (二篆)[65], and exert efforts to studying the *ba fen* (八分, clerical script)[66],

92. 包括篇章，涵泳飛白。

as well as pay attention to zhangcao ("篇章" refers to "章草", an earlier form of cursive script which is based on the clerical script)[67] and immerse oneself in the art of using fei-ba (飛白, a calligraphic technique whereby the brush is only semi-wet with ink to create black brushstrokes that have white spaces randomly dispersed within them)[68].

93. 若豪氂不察，則胡、越殊風者焉。

If one does not observe these very fine details in scribing the different scripts, then the resulting outcome will be extremely far from ideal – as far and disparate as the customs of the North and South which are completely isolated from

each other (胡越).[69]

Paragraph 6: On specialization of one particular script, adeptness in scribing both standard and cursive scripts, as well as personal temperament

94. 至如鍾繇<u>隸</u>(隸)奇，張芝草聖，此乃專精一體，以致絕倫。
As for Zhong Yao the Wizard of the Standard Script as well as Zhang Zhi the Sage of the Cursive Script, they are both excellent illustrations of calligraphers who specialized in one particular script to the extent that their artistries became exceptionally superior and distinctively unrivaled.

95. 伯英不真，而點畫狼藉；元常不草，使轉從橫。
Although Boying (Zhang Zhi) was not a top master in scribing the standard script, his dots and strokes [in scribing the standard script][70] were wild and unrestrained. Yuanchang (Zhong Yao) was not a great champion in scribing the cursive script, yet his concerted brush turns and movements [in scribing the cursive script][71] were free and liberated.

96. 自茲已降，不能兼善者，有所不逮，非專精也。
As such, subsequent calligraphers who are unable to scribe both scripts well and do not reach their (Zhang and Zhong) levels of artistry have nothing to do with specializing in scribing one particular script.[72]

97. 雖篆、<u>隸</u>(隸)、草、章，工用多變，濟成厥美，各有攸宜。
Even the seal, standard (隸)[73], cursive and zhangcao scripts are all scribed with a variety of corresponding techniques that are dynamic in nature (工用多變)[74]; these techniques synergize among each other to form (濟成)[75] their distinct aesthetic beauty observed in each of the dif-

26

ferent scripts , and each script has its own corresponding suitable applications.

98. 篆尚婉而通，<u>隸</u>(隸)欲精而密，草貴流而暢，章務檢而便。
The seal script celebrates curves and coherence, the standard script requires detail and rigor, the cursive script charms by its flow and uninhibitedness, and the zhangcao script necessitates conformity with swiftness.

99. 然後凜之以風神，溫之以妍潤；
[After considering all of the above individually], then comes the time to enhance its awe with artistic flavor and vigor (風神)[76], warm it up with prettiness and adornment;

100. 鼓之以枯勁，和之以閑雅。
invigorate it with wiriness and strength, and harmonize it with carefree elegance.

101. 故可達其情性，形其哀樂。
Hence, calligraphy can express one's temperament and can reveal one's grief and joy.

102. 驗燥濕之殊節，千古依然；
Truly, the art is a testament of living through the fickleness of the mundane world (燥濕)[77] while maintaining one's noble integrity (殊節)[78] unaltered throughout the times;

103. 體老壯之異時，百齡俄頃。
by the time one experiences and comprehends the distinct differences of the artistic flavors exhibited between the older and the younger self, a lifetime (百齡)[79] has already passed like an instant (俄頃)[80].

104. 嗟乎! 不入其門，詎窺其奧者也!?

Alas! For those who do not enter the world of calligraphy, how can they see its profound mysteries!?

Paragraph 7: The impact of the environment, conditions, and circumstances on scribing calligraphy as well as the inadequacies in narrating the art

105. 又一時而書，有乖有合。合則流媚，乖則彫疎。

And when one writes calligraphy, there are times that are disagreeable (乖)[81], while others agreeable (合)[82]. Scribing in times that are agreeable facilitates works that are pleasant and harmonious. Scribing in times that are disagreeable will result in works that are gloomy and withered.

106. 略言其由，各有其五：

Here, I will briefly outline the factors behind agreeable and disagreeable times. Both involve five factors:

107. 神怡務閑，一合也；感惠徇知，二合也：

when one's spirit is uplifted with joy and one's duty is light and easy, this is the first agreeable factor; when one feels unhindered (感惠)[83] and adheres to one's feelings (徇知)[84], this is the second agreeable factor;

108. 時和氣潤，三合也；紙墨相發，四合也；偶然欲書，五合也。

when the climate is pleasant and the atmospheric conditions are nurturing (氣潤)[85], this is the third agreeable factor; when high quality paper and ink synergize with each other, this is the fourth agreeable factor; when one, by chance, becomes inspired to write calligraphy at a certain

moment, this is the fifth agreeable factor.

109. 心遽體留，一乖也；意違勢屈，二乖也；

When the mind is rushed and anxious (遽)[86] and the body is sluggish with lethargy (留)[87], this is the first disagreeable factor; when one feels unpleasant and is required to act against one's conscience due to the circumstances (勢屈)[88], this is the second disagreeable factor;

110. 風燥日炎，三乖也；紙墨不稱，四乖也；情怠手闌，五乖也。

when the weather is windy, dry and extremely hot (ie. the weather is unpleasant), this is the third disagreeable factor; when the paper and ink are of poor quality, this is the fourth disagreeable factor; when one is exhausted (情怠)[89] and the hands are uninspired (手闌)[90], this is the fifth disagreeable factor.

111. 乖合之際，優劣互差。

The interplay among these agreeable and disagreeable conditions contributes to the differences between good and bad calligraphy.

112. 得時不如得器，得器不如得志。

Favorable moments are not as beneficial as possessing the appropriate tools (paper, ink, brush and ink-stone), while possessing the appropriate tools is not as constructive as having the cheerful mindset (志)[91].

113. 若五乖同萃，思遏手蒙；

If the five disagreeable factors converge and gather, then one's mind will be clogged and the hands will be muddled;

114. 五合交臻，神融筆暢。

while if the five agreeable factors assemble and meet, then one's spirit will be uplifted with harmony and the brush will flow smoothly without any burden.

115. 暢無不適，蒙無所從。

When the brush flows without burden, nothing that it scribes is not beautiful(不適)[92]; when the hand is muddled, it cannot find any direction to follow.

116. 當仁者得意忘言，罕陳其要；

Dedicated masters can grasp the implications of the art but are often at a loss of words to describe them, and so very rarely do they illustrate their essences in detail to others;

117. 企學者希風敘妙，雖述猶疎。

on the other hand, those who are motivated to learn can admire and model the elegance of the skilled (希風)[93] and narrate their wonders, but their narratives are often crude and superficial.

118. 徒立其工，未敷厥旨。

All their efforts are in vain, as they do not know how to characterize the critical aspects of the marvels of the art.

119. 不揆庸昧，輒效所明。

Here, with great humility and notwithstanding my ignorance, I shall then apply myself to outline what I have understood.

120. 庶欲弘既往之風規，導將來之器識。

By doing so, I humbly hope to advance and promote the artistic demeanors and traditions of the past as well as to

guide future generations to properly develop great magna-
nimities and deep insights (器識)[94] in the art of calligraphy.

121. 除繁去濫，覩迹明心者焉。

Herewith I will exclude the many existing inferior works for
deliberations (除繁去濫)[95] so that enthusiasts can focus
on appreciating the exemplars of the past, thereby enlight-
ening and illuminating their minds (覩迹明心)[96,97].

Paragraph 8: On the principles in deciding the top-ics and materials to be included in Shu Pu as well as limiting the scope of it to the period between the Eastern Han and Southern dynasties

122. 代有《筆陣圖》七行，中畫執筆三手；圖貌乖舛，點畫湮訛。

Currently(代)[98], there exists a document that contains
seven rows of texts extracted from *Bizhentu*(《筆陣圖》)[99]
wherein diagrams of various approaches to holding a brush
(執筆三手)[100] were depicted; the illustrations therein, how-
ever, are flawed, with lines and dots of the diagrams blurred
and misplaced.

123. 頃見南北流傳，疑是右軍所製。

This document now appears to be widely circulated across
the North and South and is suspected to be authored by
Youjun (Wang Xizhi).

124. 雖則未詳真偽, 尚可發啟童蒙。既常俗所存, 不藉編錄。

Although the authenticity of this document has not been
verified, it nonetheless can serve as a guide for ignorant
children. Since it has been commonly retained and passed
on by many, I shall not catalogue and document it here.

125. 至於諸家勢評，多涉浮華，莫不外狀其形，內迷其理。今之所撰，亦無取焉。

As for the commentaries made by various venerable pundits on the manners exhibited among different brushstrokes (勢評)[101], they were mostly superficial without substance, and they all described only the exterior aspects of the art, often obscuring the key principles of calligraphy. Thus, for writing my present narrative, they will not be included.

126. 若乃師宜官之高名，徒彰史諜；

With regards to Shi Yiguan's (師宜官, ?-?) stellar reputation, we can only see his name proclaimed in historical texts;

127. 邯鄲淳之令範，空著縑緗。

with respect to Handan Chun's (邯鄲淳, 132-211AD) exemplarity in writing calligraphy, it is merely described in scholarly books.

128. 暨乎崔、杜以來，蕭、羊已往，代祀緜遠，名氏滋繁。

As for the period spanning from Cui Yuan (崔瑗, 77-142 AD) and Du Du (杜度, ?-? AD) to Xiao Ziyun (蕭子雲, 486-549 AD) and Yang Yan (羊欣, 359-432 AD) (ie. approx. 1st to 6th Century AD)[102], generations had come and gone in that period, bringing forth many distinguished families during that era.

129. 或藉甚不渝，人亡業顯；

Some maintained their prominence unaltered throughout the ages, their deeds and works still being proclaimed despite they had passed away;

130. 或憑附增價，身謝道衰。

some rose to fame by relying on their family and social

status during their lifetimes, their art withered and forgotten once they expired.

131. 加以糜蠹不傳，搜秘將盡。

Furthermore, many works of that era did not survive to the present day due to damages and erosions, and the rest had almost all been exhaustively searched out.

132. 偶逢緘賞，時亦罕窺。

Even if one has the rare opportunity to see and appreciate one or two of them first-hand, these works are rarely seen to be of good artistic caliber (時亦罕窺)[103].

133. 優劣紛紜，殆難覼縷。

Hence, appraisals on the qualities of these works were chaotically diverse, ranging from outstanding to poor. It is therefore probably difficult to elaborate all these works here in detail.[104]

134. 其有顯聞當代，遺迹見存，無俟抑揚，自標先後。

As for those contemporary calligraphers who are currently well-known (ie. 7th century AD)[105], their works are mostly retained and can readily be observed. Thus, it is not necessary to wait for my acclamation or belittling as their creations will speak for and rank among themselves.

135. 且六文之作，肇自軒轅；八體之興，始於嬴正。

As well, the institution of the "The Six Fundamental Methods of Creating Chinese Characters (六文)[106]" began in the very ancient Xuanyuan period (軒轅) while the "Eight Scripts of Chinese Characters (八體)[107]" became fashionable starting in the Ying Zheng era (嬴正, aka Qin Shi Huang, which refers to the 3rd Century BC).

136. 其來尚矣，厥用斯弘。

They were all introduced long time ago, and their applications were far and wide.

137. 但今古不同，妍質懸隔。既非所習，又亦略諸。

However, these antiquated writing scripts differ from those of the contemporary, and their archaic styles of un-adornment are far apart from the current styles of elegance. Since we are not familiar (習)[108] with them, they are therefore also omitted in my narrative here.

138. 復有龍蛇雲露之流，龜鶴花英之類：

As for the types of calligraphy which are scribed like dragons, snakes, clouds, and dews, or others that are scribed in the forms of turtles, cranes, flowers, lingzhi (英)[109], etc.;

139. 乍圖真於率爾，或寫瑞於當年。

they can perhaps (乍)[110] be considered as models of objects (圖真)[111] by frivolous minds (率爾)[112] or written in celebration of auspicious signs (瑞)[113] observed at a particular time in the past.

140. 巧涉丹青，工虧翰墨。異夫楷式，非所詳焉。

The skills in scribing them involve Chinese painting techniques and are inconsistent with those in Chinese calligraphy. Since they deviate significantly from the standards of traditional calligraphy, I will not detail them here.

141. 代傳羲之《與子敬筆勢論》十章,

Currently(代)[114], there is also a document of ten chapters supposedly written by Xizhi (Wang Xizhi) titled *A Treatise on Brushstroke Forms and Manners for Zijing* (《與子敬筆勢論》, note Zijing is Wang Xianzhi, Wang Xizhi's son)[115]

circulating among the public,

142. 文鄙理疏，意乖言拙。詳其旨趣，殊非右軍。
its wordings are however inferior, its arguments are loosely made, its contentions are erroneous, and its viewpoints are extremely dull and lousy. Hence, judging from its tenor, it is certainly not the work of Youjun (Wang Xizhi).

143. 且右軍位重才高，調清詞雅。 聲塵未泯，翰櫝仍存。
Indeed, Youjun once held prestigious titles and possessed great talents, his personal styles were delicate, and his writings were always elegant. As such, his reputation had not been forgotten and boxes of his hand-written letters (翰櫝)[116] (ie. his calligraphic works) were commonly retained and passed on in his era.

144. 觀夫致一書、陳一事，造次之際，稽古斯在。
Examining closely at his works, whenever he composed a letter or narrated a matter, even when rushed, he had always acted in consideration of and in accordance with traditional principles.

145. 豈有貽謀令嗣，道叶義方，章則頓虧，一至於此!?
How then could he had taught his own son the good morals (道)[117] that were consistent with (叶)[118] the righteous way (義方)[119] and yet wrote such a treatise that had abandoned (頓)[120] and deviated (虧)[121] from the traditional norms to such a large degree!?

146. 又云與張伯英同學，斯乃更彰虛誕。
In addition, the *Treatise* mentioned that he (Wang Xizhi) and Zhang Boying learned from the same teacher (同學)[122], a claim that further illustrated its absurdity.

147. 若指漢末伯英，時代全不相接；

If it were referring to the [Zhang] Boying of the late Han dynasty, then the timing is completely mismatched [with Wang Xizhi's era];

148. 必有晉人同號，史傳何其寂寥？

if(必)[123] it were referring to another person with the same name in the Jin dynasty, then why would that person not be recorded in any historical biography?

149. 非訓非經，宜從棄擇。

Such documents that do not follow the strict disciplines (both in terms of methods and values) applied in Exegesis (訓)[124] and Canon Studies (經)[125] shall hence appropriately be left out of my narrative here.

150. 夫心之所達，不易盡於名言；言之所通，尚難形於紙墨。

Alas, what is understood in the mind can be difficult to express completely in words; what can be communicated through words can still be hard to describe with ink and paper (ie. in written texts).

151. 粗可髣髴其狀，綱紀其辭。

I can therefore only roughly emulate what others have done to narrate the general aspects of the art (髣髴其狀)[126] and provide guidance and reasoning to the various explications (辭)[127] in the area of calligraphy.

152. 冀酌希夷，取會佳境。闕而未逮，請俟將來。

I hope readers can find the art's natural marvels (冀酌希夷)[128] and so allow them to come to a realization and become enlightened with its most wonderful realm (取會佳境)[129]. For other aspects that may have been left out and

not narrated here (闕而未逮)$^{(130)}$, please wait for prospective authors to supplement them in the future.

Paragraph 9: On holding and moving the brush

153. 今撰執、使、用、轉之由，以袪未悟:

Here, I shall jot down the means and techniques (由)$^{(131)}$ behind Zhi, Shi, Yong, and Zhuan (執使用轉)$^{(132)}$ so as to shed light upon the unenlightened:

154. 執謂深淺長短之類是也：

Zhi (執) refers to how one can hold a brush, such as holding it higher away or lower towards (深淺長短)$^{(133)}$ the tip of a brush, and so on;

155. 使謂縱橫牽掣之類是也：

Shi (使) refers to how one's wrist moves a brush, such as dragging or pulling it (牽掣) horizontally or vertically (縱橫), and so on;

156. 轉謂鉤鐶盤紆之類是也：

Zhuan (轉) refers to the concerted movements of turning a brush to scribe brushstrokes that are in the forms of hooks (鉤), rings (鐶), twists (盤), turns (紆), and so on;

157. 用謂點畫向背之類是也。

Yong (用) refers to the arrangements of dots and lines (點畫) to create the inward facing or outward facing brushstroke manners (向背)$^{(134)}$, and so on.

158. 方復會其數法，歸於一途。

Further, I shall collect and gather the various methods in holding and moving the brush (會其數法)$^{(135)}$ and bring

them all together as a path for one to learn and practise.

159. 編列眾工，錯綜羣妙。

I will also compile and thoroughly list the techniques (such as holding and moving the brush) employed by various renowned calligraphers as well as the wonders derived from intricately incorporating these techniques (including the manners of brushstrokes).

160. 舉前賢之未及，啟後學於成規。

I also aim to point out aspects that were not mentioned by venerable predecessors so as to enlighten future learners in regard to the well-established tenets in scribing calligraphy.

161. 窺其根源，析其枝派。

Moreover, I shall examine and investigate the root and origin of the art as well as analyze its different branches and schools.

162. 貴使文約理贍，迹顯心通；

It is my utmost intention (貴)[136] to make the language concise, to present rich arguments, to make exemplary calligraphies evident to readers, and to make readers comprehend my reasonings without any impediment;

163. 披卷可明，下筆無滯。

when one reads this scroll (ie. this narrative), one will instantly comprehend and so will not be obscured when one scribes.

164. 詭詞異說，非所詳焉。

As for bizarre assertions and odd theories, they will not be

detailed here.

165. 然今之所陳，務裨學者。

As such, the present narrative aims to benefit all learners.

Paragraph 10: Brief discussion on the exemplary masterpieces scribed by Wang Xizhi (王羲之)

166. 但右軍之書，代多稱習，良可據為宗匠，取立指歸。豈唯會古通今，亦乃情深調合。

Every piece of calligraphy scribed by Youjun (Wang Xizhi) is widely known (習)[137] and praised (稱)[138] in our times (代)[139]. As such, his outstanding artistry certainly qualifies him to be regarded as a role model to follow as well as a venerable grand master of calligraphy. Accordingly, many draw from his accomplished works (立)[140] as a direction for their aspirations in learning calligraphy. Not only did he grasp the rules of the past and master the fashion of the present (Wang's present, ie. Eastern Jin dynasty), he was also able to showcase his deep emotions with manners that are agreeable and harmonious.

167. 致使摹搨日廣，研習歲滋。先後著名，多從散落。歷代孤紹，非其効歟？

As a result, his works are increasingly being modeled (摹) and printed (via ink rubbings on carved wood or stone, 搨)[141] by the day, and the number of people studying his calligraphy is growing year by year. The various renowned (著名)[142] models and prints, regardless of their ranks in quality(先後)[143], are mostly made in accordance to his long lost handwritten originals (多從散落)[144]. Indeed, his style of calligraphy is singularly conveyed throughout generations; isn't that the result of the wide and intensive modelling and

printing of his works (非其効歟)[145]?

168. 試言其由，略陳數意。

Now, I shall attempt to outline his personal artistic evolution (由)[146] and then narrate some of my own opinions.

169. 止如《樂毅論》、《黃庭經》、《東方朔畫讚》、《太師箴》、《蘭亭集序》、《告誓文》，斯並代俗所傳，真行絕致者也。

His works such as (止如)[147] *Narration on Yue Yi* (《樂毅論》), *The Yellow Court Classic* (《黃庭經》), *Commentaries on the Portrait of Dongfang Shuo* (《東方朔畫讚》), *Admonitions to the Emperor from the Imperial Mentor* (《太師箴》), *Preamble to the Collection of Poems written in the Orchard Pavilion* (《蘭亭集序》, also commonly known as *Lanting Xu*), and *The Statement of Pledge* (《告誓文》) are all prevalently retained and passed on in our times (代俗)[148], and they are certainly the top and most marvelous among standard and semi-cursive script works.

170. 寫《樂毅》則情多怫鬱；書《畫讚》則意涉瓌奇；

When he wrote *Narration on Yue Yi*, he displayed rich emotions and melancholy; when he scribed *Commentaries on the Portrait of Dongfang Shuo*, he exhibited passions that were magnificent and exceptional;

171. 《黃庭經》則怡懌虛無；《太師箴》又縱橫爭折。

in *The Yellow Court Classic*, his calligraphy was joyful and in a state of "nothingness" (虛無)[149]; in *Admonitions to the Emperor from the Imperial Mentor*, his artistry was free and unrestrained and reflected his ambition in attaining distinguished accomplishments to elevate himself to the top of the bureaucracy (爭折)[150].

172. 暨乎蘭亭興集，思逸神超：

Eventually, when he wrote the *Preamble to the Collection of Poems written in the Orchard Pavilion*, he was scribing with his thoughts liberated (逸) and a mind that had transcended above the mundane world (超);

173. 私門誡誓，情拘志慘。

[in *The Statement of Pledge*《告誓文》], as he pledged to his parents and admonished himself [to leave behind his bureaucratic life and never return to it again], he exhibited a sentiment of frustration (情拘) and a mood full of sorrows. (151)

Paragraph 11: The art of calligraphy is evolved from one's mindset and emotions, holding one's original nature in the highest regard

174. 所謂涉樂方咲，言哀已歎。

There is a saying: "one laughs when one experiences happiness; one speaks of sadness when one has already sighed." (152)

175. 豈惟駐想流波，將貽嘽嗳之奏：

[Outstanding individuals like Bo Ya] simply do not need to ruminate about flowing streams in order to deliver melodies of tears; (153)

176. 馳神睢渙，方思藻繪之文。

or have to ponder at Sui and Huan so as to come up with colorful words and languages. (154)

177. 雖其目擊道存, 尚或心迷義舛。莫不強名為體，共習分區。

Although some outstanding individuals are able to comprehend the underlying philosophy simply by a glance (目擊道存)[155], they may still be baffled in their minds (心迷) [156] with their perceived thoughts far from the fundamental principles (義)[157]. As such, they are all compelled to classify prominent calligraphers' handwritings as various "standard set fonts (體, such as Wang Xizhi font)[158]". Together, they practice calligraphy according to such classifications (分區)[159].

178. 豈知情動形言，取會風騷之意；

Alas, not many know that when emotion rises, one will naturally express it in words that are extracted and collected from the temperaments conveyed in the *Lessons from the States* (《國風》) and *Sorrow after Departure* (《離騷》) (風騷, ie. literary excellence of unadorned passion)[160];

179. 陽舒陰慘，本乎天地之心。既失其情，理乖其實。原夫所致，安有體哉?!

when it is sunny, one feels pleasant, and when it is dark and shadowy, one feels depressed, such is indeed fundamentally rooted in the nature of Heaven and Earth. Thus, they (those who classify the natural art of calligraphy into various "standard set fonts") all miss the temperaments of the art, and their reasonings go against the true essence of Nature. From examining in detail the fundamental root of calligraphy (原夫所致)[161], how can there be "standard set fonts"?! [162]

Paragraph 12: On the overall structures and layouts in the art of calligraphy

180. 夫運用之方，雖由己出；規模所設，信屬目前。

Alas, although the ways to command a brush are discerned by oneself, how one organizes (所設)[163] character structures and overall layouts (規模)[164] are indeed (信) only determined at the instant (目前)[165] of scribing.

181. 差之一豪，失之千里。苟知其術，適可兼通。

[There is a saying:] "A deviation, even of a hair's breadth, will result in a mistake of a thousand mile." If one were to correctly understand and grasp the methods in arranging and organizing structures and layouts, then one will be able to comprehend other artistries.

182. 心不厭精，手不忘孰(即熟)。

The mind will then not grow tired of pursuing excellence, whereas the hands will not forget to apply their familiar skills.

183. 若運用盡於精熟，規矩闇於胸襟，自然容與徘徊。

If one is extremely adept at commanding the brush with the rules and principles of these methods very much acquainted(闇)[166] within one's heart and mind, then one will naturally scribe with ease and serenity (容與徘徊)[167].

184. 意先筆後，蕭灑流落。

Thoughts shall come before the brush moves, and so the brush will move in a manner that is dashing and carefree (蕭灑)[168], dynamic and magnanimous, as if one's meridians are unblocked and circulating without any impediment (流落)[169].

185. 翰逸神飛，亦猶弘羊之心，預乎無際；

One's calligraphy shall then become exquisite (翰逸) with an uplifted demeanor (神飛), as if it is being scribed with a mind like Hongyang's (弘羊之心)[170], which can calculate many things in advance to a limitless degree;

186. 庖丁之目，不見全牛。

or is akin to the eyes of an expert cook who can dissect a cow without seeing it in entirety.[171]

187. 嘗有好事，就吾求習。

At one time, some calligraphy enthusiasts approached me to learn calligraphy.

188. 吾乃粗舉綱要，隨而授之。

I then roughly illustrated to them the essential frameworks of these methods and taught them accordingly.

189. 無不心悟手從，言忘意得。

Without exception, all had their minds enlightened with their hands scribing according to their wishes; since they already grasped the essential aspects of calligraphy, words characterizing the art were hence unnecessary and could be left forgotten (言忘意得)[172].

190. 縱未窮於眾術，斷可極於所詣矣!

Although they could not completely examine all other various methods (眾術), they surely would be able to eventually reach where the art of calligraphy resides (斷可極於所詣矣) [173]!

Paragraph 13: The three stages in learning calligraphy - the proper and balanced stage, the daring and risky stage, and the thoroughly comprehended and harmonized stage

191. 若思通楷則，少不如老；

In the case of grasping and deliberating on the principles behind calligraphy exemplars(楷則)[174], the young are not as capable as the elderly;

192. 學成規矩，老不如少。

for learning rules and principles, however, the elderly are not as proficient as the young.

193. 思則老而逾妙，學乃少而可勉。

The elderly tend to be more marvelous at deliberations, while the young are better at putting more efforts into learning.

194. 勉之不已，抑有三時，時然一變，極其分矣。

As one puts in continuous hard work and effort without rest, one shall perhaps (抑)[175] experience three stages (三時)[176] during one's learning. Each stage brings about (然)[177] significant changes, and the degree of change is dependent on one's ultimate potential (分)[178].

195. 至如初學分布，但求平正；

For initial learning of structural organizations and layouts (分布)[179], one shall only aim to scribe in a proper, neat and balanced manner (平正)[180];

196. 既知平正，務追險絕；

once scribing in a balanced manner has been grasped, one

shall then pursue to scribe in a manner that is extremely risky, daring and extraordinary (險絕)[181];

197. 既能險絕，復歸平正。

when one is able to scribe in a style that is extremely risky, daring and extraordinary, one will then ultimately return to scribe in a balanced fashion.

198. 初謂未及，中則過之，後乃通會。

Initially, one falls short; in-between, one goes too far; eventually, one will thoroughly comprehend and harmonize (通會)[182] the balanced and the risky in writing calligraphy.

199. 通會之際，人書俱老。

By the time one reaches this mastery stage of thorough comprehension and being able to harmonize the balanced and the risky, both one and one's calligraphy will already be aged.[183]

200. 仲尼云：「五十知命。七十從心。」

Zhongni (Confucius) once said, "At fifty, I knew the decrees of Heaven. At seventy, I could follow what my heart desired (without transgressing what was right，不踰矩)." [184]

201. 故以達夷險之情，體權變之道。

That is why the elderly can apply (以) their understanding (達) of their passions for applying the balanced and the risky (夷險之情)[185] to experience the ways of being flexible in dealing with ever-changing circumstances (權變之道,186).

202. 亦猶謀而後動，動不失宜；

Such is also like one is able to plan first (such as learning the rules and pursuing to scribe in a plain and balanced

manner) then act (such as pursuing to scribe in a risky and daring manner), and every move one makes is not inappropriate nor unnecessary;

203. 時然後言，言必中理矣。

or similar to one speaks only when it is the time to speak (時然後言)[187], and each word spoken is always consistent with the facts and reason.

204. 是以右軍之書，末年多妙。

Hence, therefore, the works Youjun (Wang Xizhi) wrote late in his life were often more marvelous.

205. 當緣思慮通審，志氣和平，不激不厲，而風規自遠。

This was because, at that period in his life, his mind thoroughly comprehended the art, his temperament was calm and gentle, his styles were not too extreme and not too intense, and so his artistic fashion (風規)[188] naturally became (自) grand and noble (遠)[189].

Paragraph 14: Common missteps and misconceptions in learning calligraphy (in Sun Guoting's times)

206. 子敬已下，莫不鼓努為力, 標置成體。

Subsequent to Zijing (Wang Xianzhi), everyone believes exerting one's greatest might in scribing the vertical brush-stroke (鼓努)[190] is a display of strength in applying the brush (為力)[191] and arrogantly proclaims oneself to have accomplished scribing adeptly in a certain "set standard font" of a prominent calligrapher.

207. 豈獨工用不侔，亦乃神情懸隔者也。

Not only (豈獨) are the outcomes of their endeavors not

in accord (不侔)[192] with the amount of effort (工用)[193] they put in, their calligraphy are also isolated with their own emotions and temperaments.

208. 或有鄙其所作，或乃矜其所運：
There are some who look down upon their own works, and there are some who are proud of their own techniques in applying the brush:

209. 自矜者將窮性域，絕於誘進之途；
those who are proud shall have their calligraphy insulated (窮)[194] from the realms of their own temperaments (性域)[195], and the paths to directed improvement (誘進)[196] shall then be shut off from them;

210. 自鄙者尚屈情涯，必有可通之理。
those who look down upon themselves almost (尚)[197] have their art completely disconnected (屈)[198] from the shores of emotions (情涯)[199], but they will eventually find a path towards comprehending the principle (理)[200] of the art.

211. 嗟乎！蓋有學而不能，未有不學而能者也；考之即事，斷可明焉。
Alas! Indeed, there are those who learn but cannot master (能)[201], but there are none who do not learn yet master; considering our current topic (考之即事)[202], it is absolutely easy to understand this argument.

Paragraph 15: The important aspects that learners should pay attention to

212. 然消息多方，性情不一。
Yet, the variations (消息)[203] within the art are many, and

one's own temperaments are never one and the same.

213. 乍剛柔以合體，忽勞逸而分驅；

Strong and gentle brushstrokes can abruptly (乍) come together (合) to form the bodies of characters (體)[204], while strenuously heavy and serenely light brushstrokes (勞逸)[205] can suddenly diverge to run in different directions (分驅)[206];

214. 或恬憺雍容，內涵筋骨；

some are plain (恬憺)[207] and graceful (雍容)[208], internally embodying the "Tendons (筋)[209]" and the "Bones (骨)[210]";

215. 或折挫槎枿，外曜峯芒。

some take the form of twists (折)[211] and turns (挫)[212] as if they are twigs naturally branching out from a tree (槎枿)[213], externally exhibiting the vividness of sharp edges and corners (峯芒)[214].

216. 察之者尚精，擬之者貴似。

Those who can examine all these features cherish paying attention to details, while those who are able to model all these features treasure imitating with close resemblance.

217. 況擬不能似，察不能精，分布猶疎，形骸未檢。

There are instances (況)[215] where some model without resemblance, examine without paying attention to details, arrange structural layouts with very little proficiency (猶疎)[216], and create character forms that do not conform to the established rules.

218. 躍泉之態，未覯其妍；

In such cases, we shall not see any prettiness in their works despite their creations appear to look like lively dragons fiercely jumping out of streams (躍泉)[217];

219. 窺井之談，已聞其醜。

their assertions and contentions will be muddling (窺井)[218], and certainly (已)[219] we shall hear their grotesqueness.

220. 縱欲搪突羲、獻，誣罔鍾、張，安能掩當年之目，杜將來之口？

Even though they like (欲) to offensively (搪突)[220] claim that they have earnestly learned from Xi (Wang Xizhi) and Xian (Wang Xianzhi) and slanderously (誣罔)[221] proclaim that they have faithfully modelled Zhong (Zhong Yao) and Zhang (Zhang Zhi), how can they possibly cover up all the watchful eyes during their times or stamp out all the denunciations (口)[222] of the future?

221. 慕習之輩，尤宜慎諸。

Anyone who wishes to learn calligraphy should hence pay particular attention to the various aforementioned aspects.

Paragraph 16: On the speeds of moving the brush - "Slow and Heavy", "Strong and Swift", and "Stay and Hold"

222. 至有未悟淹留，偏追勁疾；不能迅速，翻效遲重。

As for those who have not fully understood the technique of "Stay and Hold (淹留)[223]", they tend to superficially strive to scribe as quick as fast striking swords (偏追勁疾)[224]; for those who cannot attain scribing in rapid speeds, they

instead (翻)[225] embrace scribing in a "Slow and Heavy (遲重)[226]" manner.[227]

223. 夫勁速者超逸之機，遲留者賞會之致。

Alas, "Strong and Swift (勁速)[228]" is the cause of (機)[229] liberation and transcendence above mundane elegance (超逸), whereas "Slow and Heavy" and "Stay and Hold" (遲留)[230] bring about the disposition of heartfelt appreciation and spiritual comprehension (賞會之致)[231].

224. 將反其速，行臻會美之方：

When scribing a single brushstroke, one should intermittently go against one's speed (將反其速)[232] so that one will be able to (行)[233] reach the realm (方)[234] where all the wonders and beauties of calligraphy reside;

225. 專溺於遲，終爽絕倫之妙。

solely obsessing with scribing by "Slow(遲)[235]" shall, therefore, make one ultimately miss the marvels of unsurpassed brilliance.

226. 能速不速，所謂淹留；因遲就遲，詎名賞會？

Within a brushstroke where one can scribe swiftly but chose not to entirely, this is the so-called "Stay and Hold (淹留)"; if one goes completely along (就)[236] with "Slow" for the sake of being "Slow", how can one bring about (名)[237] heartfelt appreciation and spiritual comprehension?[238]

227. 非夫心閑手敏，難以兼通者焉。

Indeed, those who do not have a leisurely and tranquil mind as well as agile hands (心閑手敏)[239] shall find it difficult to be adept at "Slow and Heavy", "Strong and Swift",

and "Stay and Hold" all at the same time.

Paragraph 17: On "Bones", "Tendons", and "Flesh"

228. 假令眾妙攸歸，務存骨氣，骨既存矣，而遒潤加之。

Suppose if all the various wonders outlined above have been resided in one's mind, then one should pursue to amass the sturdiness of the "Bones" (骨氣)[240] in one's calligraphy. Once these Bones exist, then it is time to add vigor, elasticity (遒, Tendons)[241] and fullness (潤, Flesh)[242] to it.

229. 亦猶枝幹扶疏，凌霜雪而彌勁；

Such is like luxuriant branches growing out of a tree's trunk, which become stronger when they have experienced(凌)[243] frost and snow;

230. 花葉鮮茂，與雲日而相暉。

or like exuberant flowers residing within dense leafs, which synergistically become more beautiful with the sun and the colorful clouds.

231. 如其骨力偏多，遒麗蓋少，

If one scribes with more sturdiness in the Bones (骨力)[244] and too little vigor, elasticity and elegance (遒麗, Tendons and Flesh)[245],

232. 則若枯槎架險，巨石當路。雖妍媚云闕，而體質存焉。

then it will be like using dried-up twigs to construct a precarious bridge in a hazardous location (枯槎架險)[246] or like a large boulder blocking an important path (巨石當路)[247]. Nontheless, despite elegance and prettiness (妍媚)[248] are absent, the shapes and forms of characters still

exist.

233. 若遒麗居優，骨氣將劣，

If one favors scribing with vigor, elasticity as well as elegance and so diminishes the sturdiness of the "Bones" in one's calligraphy,

234. 譬夫芳林落蘂(藥)，空照灼而無依；蘭沼漂萍，徒青翠而奚託？

then the outcome will be akin to fallen flowers (落蘂)[249] in a fragrant flowery forest (芳林)[250], pointlessly brilliant and glamorous (照灼)[251] as there is nowhere to which they belong; or it will be like the drifting duckweeds floating (漂) on a herbal Eupatorium pond (蘭沼漂萍)[252], exhibiting their luscious greens in vain as what footing will they ground themselves on?

235. 是知偏工易就，盡善難求。

One should know that it is easy to become partially adept at one aspect (Bones, Tendons, or Flesh) of the art (偏工易就) [253], while it is difficult to accomplish complete and perfect mastery.

236. 雖學宗一家，而變成多體，莫不隨其性欲，便以為姿。

Although some learners study and follow a particular school of calligraphy, they nonetheless may turn it into various [odd] character shapes and forms (體)[254]; without exception, they scribe according to their personalities as well as their own preferences (性欲)[255] and then take whatever they are familiar with as beautiful (姿)[256].

237. 質直者則徑侹不遒，剛很者又掘強無潤；

Those who are simple and honest produce brushstrokes

that are sturdy but without vigor and elasticity (倥偬)[257],
those who are headstrong (剛很)[258] scribe characters
that are rigid but without fullness (掘強無潤)[259];

238. 矜斂者弊於拘束，脫易者失於規矩：

those who are cautious and self-reserved (矜斂)[260] carry
the flaw of scribing with too much restraint, those who are
reckless and negligent (脫易)[261] scribe without following
the rules and principles;

239. 溫柔者傷於軟緩，躁勇者過於剽迫：

those who are gentle and tender suffer from scribing weak-
ly and slowly, those who are impulsive and ferocious scribe
too frivolously and in an impetuous pace (剽迫)[262];

240. 狐疑者溺於滯澀，遲重者終於蹇鈍，輕瑣者染於俗吏。

those who are overly skeptical and sensitive (狐疑)[263]
fall into scribing sluggishly without vitality (滯澀)[264], those
who are dull-witted and without dexterity (遲重)[265] fre-
quently (終)[266] scribe tardily (蹇鈍)[267], and those who
are flippant and feeble (輕瑣)[268] are besmirched (染) by
the earthly mundaneness of ordinary government officials (
俗吏)[269].

241. 斯皆獨行之士，偏翫所乖!

These are all stubborn people who act only according to
their prejudices(獨行)[270] and practice the art superficially
and negligently which together bring about their flaws (偏翫
所乖)[271]!

Paragraph 18: Overall discussion on the ultimate path in pursuing the art of calligraphy - reverting back to one's true nature and conforming to the laws of the Natural Universe

242. 《易》曰:「觀乎天文, 以察時變; 觀乎人文, 以化成天下。」

The *Book of Changes* states, "We look at the ornamental figures of the sky, and thereby ascertain the changes of the seasons. We look at the ornamental observances of society, and understand how the processes of transformation are accomplished all under heaven." [272]

243. 況書之為妙, 近取諸身。

Likewise, the art of calligraphy is regarded as a marvel because it is drawn on one's inner self and sensory faculties (近取諸身)[273].

244. 假令運用未周, 尚虧工於祕奧;

Suppose one has not completely grasp the techniques of moving the brush and still has not become adept at the subtle aspects of the art,[274]

245. 而波瀾之際, 已濬發於靈臺 。

but within one's dynamic thoughts and emotions (波瀾之際) [275] the art of calligraphy has in fact already (已)[276] been hatched and cultivated from the bottom (濬發)[277] of one's heart (靈臺)[278].

246. 必能傍通點畫之情, 博究始終之理, 鎔鑄蟲篆, 陶均草緣 (隸)。

As such, one will eventually be able to comprehend thoroughly the nature of the dots and lines, examine profoundly

55

in detail the principles behind the evolution of the art (始終
之理)[279], digest and assimilate the artistic aspects
(鎔鑄)[280] of the worm (蟲)[281] and the seal (篆) scripts,
as well as become cultivated in and adept at (陶均)[282]
scribing the cursive and standard scripts.

247. 體五材之並用, 儀形不極;
It is as if one experiences the simultaneous application
of the five elements (五材)[283] that can create unlimited
physical forms;

248. 象八音之迭起, 感會無方。
or it is as if (象)[284] one listens to the repeated rhythms
of music, feeling and resonating with it without limits and
beyond any comparison.

249. 至若數畫並施, 其形各異;
As for when several brushstrokes are applied together,
their individual shapes and manners are different from
each other;

250. 眾點齊列, 為體互乖。
when numerous dots are presented collectively, their
respective forms and manners are distinct among them-
selves.

251. 一點成一字之規, 一字乃終篇之准。
A dot establishes the standard behind a character, and a
character serves as the norm of the entire work.

252. 違而不犯, 和而不同。
Among the dots and characters, they are disparate yet not
disagreeable, in harmony but not the same.

253. 留不常遲, 遣不恆疾; 帶燥方潤, 將濃遂枯。

As one scribes, one should Hold (留)[285] but not always Slow (遲)[286], liberate yet not constantly being fast; carry dryness along with dampness, accomplish heavy fullness and still comply with thin witheredness (將濃遂枯)[287].

254. 泯規矩於方圓, 遁鉤繩之曲直。

Such is akin to drawing circles without a pair of compasses (規)[288] and sketching squares without rulers (矩)[289], or making curvy and straight lines without divider calipers (鉤)[290] and strings.

255. 乍顯乍晦, 若行若藏。

The calligraphy should give the impression of suddenly (乍)[291] being open (顯)[292] in one place and suddenly being ambiguous in others, seemingly going towards (行)[293] yet seemingly hiding behind (藏)[294].

256. 窮變態於豪端, 合情調於紙上;

One should exhaust all the dynamic variations using the tip of the brush and amass (合)[295] all one's emotions onto the paper;

257. 無間心手, 忘懷楷則。

the hands working seamlessly (無間)[296] with the mind, and one does not care about (忘懷)[297] the set principles of the art.

258. 自可背羲獻而無失, 違鍾張而尚工。

One can then naturally go against the ways of Xi (Wang Xizhi) and Xian (Wang Xianzhi) without fault, and contravene the manners of Zhong (Zhong Yao) and Zhang (Zhang Zhi) yet still show superior skills.

259. 譬夫絳樹青琴, 殊姿共艷;

Such is like the elegant Jiang Shu (絳樹)[298] and the pretty Qing Qin (青琴)[299], distinct in their beautiful appearances yet sharing the same glamour;

260. 隨珠和璧, 異質同妍。

or like the precious Rock Globe of Marquess Sui (隨珠)[300] and the treasured He's Jade Disc (和璧)[301], different in their substances but bearing the same prettiness (妍)[302].

261. 何必刻鶴圖龍, 竟慙眞體; 得魚獲兔, 猶悋筌蹄?

Why should one rigidly carve out cranes and draw dragons to eventually shame one's true nature (竟慙眞體)[303]? As one has already caught the fish and captured the rabbit, why should one still hold dear (悋)[304] to the traps (筌蹄)[305] that delivered them?

Paragraph 19: Comprehending and Not Comprehending

262. 聞夫家有南威之容 , 乃可論於淑媛 ; 有龍泉之利 , 然後議於斷割。

I have once heard that for a man to be capable of deliberating the qualities of beautiful women, his home must first have a lady whose appearance resembles the beauty of Nan Wei (南威)[306]; or for one to discuss the finest and flushed cuts made by extremely sharp sword blades (斷割)[307], one must first possess a sharp weapon like the legendary sword of Long Quan (龍泉)[308].[309]

263. 語過其分 , 實累樞機。

When one's speech goes beyond one's capacity and ex-

periences, it is detrimental to both one's words and moral conduct (實累樞機)[310].

264. 吾嘗盡思作書，謂為甚合; 時稱識者，輒以引示。

I once produced a work of calligraphy with all my attention, thought it was fairly good, and then presented it to those who were, at the time, supposedly "knowledgeable" in the art.

265. 其中巧麗，曾不留目；或有誤失，翻被嗟賞。

Surprisingly, the marvelous and beautiful aspects within the work were not attentively looked at, whereas the various possible flaws and defects were instead highly regarded.

266. 既昧所見，尤喻所聞；或以年職自高，輕致陵誚。

It was evident that they were ignorant about what they saw and merely liked (尤)[311] to tell (喻)[312] what they had heard; some even pompously relied on their seniorities and positions of power to casually give offensive ridicules (輕致陵誚)[313].

267. 余乃假之以緗縹，題之以古目。

So I embellished the work to make it seem to be more valuable (假)[314] by putting it in a box that was made with light yellowish green silk cloths (緗縹)[315], and then I inserted a title that appeared to be written in the distant past.

268. 則賢者改觀，愚夫繼聲；競賞豪末之奇，罕議峯端之失。

Then, the so-called "wise and talented" ones immediately changed their views on the work, with fools echoing after them; they all competed to claim and appreciate the wonders created under the fine tip of the brush (豪末)[316] and hardly discussed the flaws made by the sharp peak of the

pen (峯端)[317].

269. 猶惠侯之好偽，似葉公之懼真。

Such is like Marquess Hui who cherished the calligraphy of Wang Xizhi yet frequently collected forgeries (惠侯之好偽) [318]; or similar to Mr. Yip who was obsessed with imitated dragons but feared the real ones (葉公之懼真)[319].

270. 是知伯子之息流波，蓋有由矣。

Accordingly, [after the death of Zhong Zi Qi (鍾子期), who could truly appreciate Bo Ya's music[320]], it was indeed reasonable for Master Bo (Bo Ya,伯子) to never play his beautiful music [as beautiful as high mountains and running rivers (流波)[321]] ever again.

271. 夫蔡邕不謬賞，孫陽不妄顧者，以其玄鑒精通，故不滯於耳目也。

Alas, Cai Yong (蔡邕,132-129AD) wouldn't preposterously offer praises (蔡邕不謬賞)[322], and Sun Yang (孫陽, 680-610BC) wouldn't imprudently show interest (孫陽不妄顧者)[323], for they both possessed great insight and expertise and so were not restrained by what they heard and what they saw.

272. 向使奇音在爨，庸聽驚其妙響；

If the wonderful sounds [ascertained by Cai Yong][324] of the burning wood could also be discerned with awe as marvelous musical notes by the ordinary mass,

273. 逸足伏櫪，凡識知其絕羣；

or if the magnificent speedy stallion [discerned by Sun Yang][325] resting in a stable could also be identified as an outstanding and exceptional horse by the average crowd,

274. 則伯喈不足稱，良樂未可尚也。

then Bo Jie (Cai Yong) should fall short to be glorified, and Liang (Wang Liang, 良)[326] as well as Le (Bo Le/Sun Yang, 樂)[327] should not be revered.

275. 至若老姥遇題扇，初怨而後請；

As for the story of an elderly lady who first loathed the bamboo fans (老姥遇題扇)[328] that Wang Xizhi scribed on but later welcomed them;

276. 門生獲書機，父削而子懊。知與不知也。

or the story of a disciple (of Wang Xizhi) who first acquired Wang Xizhi's calligraphy scribed on his long table (門生獲書機)[329] but later lost it for his father scraped it off, leaving the son shocked and remorseful (懊)[330]. Such stories illustrate the difference between truly comprehending and not comprehending the art.

277. 夫士屈于不知己，而申於知己。

Alas, an intellect grieves when others do not comprehend him and becomes free and at ease when others comprehend him.

278. 彼不知也，曷足怪乎？！

For those who do not comprehend, why should we bother to blame or criticize them?![331]

279. 故莊子曰：「朝菌不知晦朔，蟪蛄不知春秋。」

As Zhuangzi once said, "The mushroom of a morning does not know (what takes place between) the beginning and end of a month; the short-lived cicada does not know (what takes place between) the spring and autumn." [332]

280. 老子云：「下士聞道，大咲之；不咲之則不足以為道也。」

Or as Laozi once stated, "Scholars of the lowest class, when they have heard about Dao, laugh greatly at it. If it were not (thus) laughed at, it would not be fit to be the Dao." [333]

281. 豈可執冰而咎夏蟲哉？！

How can one hold a piece of ice to an insect that lives only one summer and blame the insect of not comprehending what ice is?! [334]

Paragraph 20: Conclusion - the reason behind naming this document as "Shu Pu (A Narrative on Calligraphy)"

282. 自漢魏已來，論書者多矣。妍蚩雜糅，條目糾紛。

Since the Han and Wei dynasties, many had deliberated on the art of calligraphy indeed. However, fine and poor narrations (妍蚩) are haphazardly intermingled (雜糅) with various topics (條目) presented unsystematically (糾紛). [335]

283. 或重述舊章，了不殊於既往；

Some merely recounted old literature, completely (了)[336] indistinguishable from those written in the past;

284. 或苟興新說，竟無益於將來。

some casually (苟)[337] proposed new ideas, ultimately (竟)[338] not providing any benefit for future generations.

285. 徒使繁者彌繁，闕者仍闕。

They all only (徒)[339] caused complicated issues to be

even more complicated, with past errors and omissions still remaining as they were.

286. 今撰為六篇，分成兩卷。第其工用，名曰書譜。

Here, I shall write six parts and organize them into two volumes. Judging from its usages and applications (第其工用) $^{(340)}$, this document shall be named as *Shu Pu* (*A Narrative on Calligraphy*).

287. 庶使一家後進，奉以規模；

It is my wish (庶)$^{(341)}$ that it will drive our beloved future generations pursuing the same discipline (一家後進) to take it as a standard text in studying calligraphy;

288. 四海知音，或存觀省。

those around the Four Seas (ie. the world) who share my passion and resonate with me can perhaps retain and use it as a reference text for reviewing.

289. 緘祕之旨，余無取焉。

The notion (旨)$^{(342)}$ of concealing the mysteries of the art from everyone is certainly not what I would like to adopt.

290. 垂拱三年寫記。

Written and narrated in the third year of the Chuigong (垂拱三年, 687AD).

漢興六十餘載海
內艾安府庫充實
而四裔未賓制度
多闕上方欲用文
武求之如弗及始
以蒲輪迎枚生見
主父而歎息羣士
慕嚮異人並出卜
式拔於芻牧弘羊

擢於賈豎衛青奮
舊於奴僕日磾出
於降虜斯亦曩時
版築飯牛之明已
漢之得人於茲為
盛儒雅則公孫弘
董仲舒兒寬篤行
則石建石慶質直
則汲黯卜式推賢

A portion of KS Vincent Poon's model of Chu Suiliang's (褚遂良)
Elaborations on the Biography of Ni Kuan (兒寬贊帖)
Standard script (楷書)

PART TWO:

Footnotes and Bibliography

A portion of KS Vincent Poon's model of Huai Su's (懷素)
Huai Su's Autobiography *(懷素自叙帖)*
Cursive script (草書)

Footnotes

KS Vincent POON（潘君尚）
Kwok Kin POON（潘國鍵）

(1). 夫自古之善書者 - The term "自古" in this context should be interpreted as "since long time ago" rather than "from antiquity" (*Two Chinese Treatises on Calligraphy*, New Haven & London: Yale University Press, 1995:1) or "ancient times"(*The Manual of Calligraphy by Sun Guoting of the Tang*, Napoli: Universita degli Studi di Napoli "L'Orientale", 2011:41); "古" here is relative and not absolute in this context, and so does not necessarily include ancient prehistoric periods, and periods of Xia (夏), Shang (商) and Zhou (周), when standard and cursive scripts have not yet been discovered. See footnote (4) for further discussion on "古" and footnote (335) for discussion on the scope of Sun Guoting's narration here in the *Shu Pu*.

Hence, the term "善書" is focused mainly on discussing on scribing good standard, cursive and semi-cursive scripts, which were widely used during Sun Guoting's era. In addition, the Four Meritorious Calligraphers (四賢, which were Zhong Yao 鍾繇, Zhang Zhi 張芝, Wang Xizhi 王羲之, and Wang Xianzhi 王獻之) mentioned were not renowned for writing the ancient clerical, seal scripts, etc. Indeed, before them, there were many renowned calligraphers, such as Li Si (李斯), who penned these ancient clerical and seal scripts with great beauty; for further details, please see Yang Xin's *A Collection of Names of Adept Calligraphers* (羊欣 ,《采古來能書人名》).

(2), (3). Extracted from *On Calligraphy* (《論書表》) by Yu He (虞龢) (《歷代書法論文選》.上海: 上海書畫出版社,

1979, pp.49-55).

(4). 古質而今妍 - This phrase was extracted from *On Calligraphy* (《論書表》) written by Yu He (虞龢). The "古" and "今" refer to "past" and "present" respectively, not "ancient" and "modern" as suggested in other translations. As in footnote (1), these terms are relative, not absolute. This argument is supported by *On Calligraphy* :

> 夫古質而今妍...鍾、張方(比)之二王，可謂古矣，...。(二王)
> 父子之間又為今古，...。
> Zhong and Zhang can be considered as the <u>past</u> relative to
> the two Wangs, ... Between the two Wangs of father and son,
> it can also be said the son is the <u>present</u> and the father is the
> <u>past</u>.
> (interpreted by KS Vincent Poon)
> Source: 《歷代書法論文選》.上海: 上海書畫出版社, 1979,
> p.50.

The term "質" should be interpreted as a description for unadorned natural beauty without artificial embellishment (質樸), not "substance (物質)" as in Chang and Frankel's translation (Chang and Frankel:1). "妍", which is used here to contrast with "質", should be interpreted as a description for elegance and prettiness that are of synthetic and artificial origins, and it certainly also carries substance.

(5). 夫質以代興 – "代興" should be interpreted as "fashionable at times", not "developed from generations from generations" suggested by Chang and Frankel (Chang and Frankel:1) or "arises through social habits" suggested by De Laurentis (De Laurentis:42) in this context. Original Chinese interpretation for "代" here should be "世代，年代，時代 (times)" while "興" should be "流行(fashionable)".

It is absurd to assert that primitive natural unadorned beauty (質) can be "developed" by humans as time progresses or "arisen" via their social habits.

(6). "而淳醨一遷, 質文三變" - The vernacular Chinese interpretation can be written approximately as "當樸厚(淳)或浮薄(醨)的風尚一旦移易，書法上之或質或文，同亦因之有着很多的改變和變化". In this context, the original Chinese interpretation of "三" should be "多數或多次(many or multiple times)" as in "三思者，言思之多，能審慎也". Hence, "三變" should mean "many varieties of changes". Translating it to "changed in three stages" (Chang and Frankel:1) or "three mutations" (De Laurentis:42) is therefore incorrect. Furthermore, "淳醨" is used to describe the different fashions "風尚" and is not used to describe the strength of "wines" as suggested in De Laurentis's translation (De Laurentis:42).

(7). Extracted from *The Analects Yong Ye* (《論語·雍也》), translated to English by James Legge in *The Chinese Classics*.

(8). 且元常專工於隸書 – The "隸書" here refers to "楷書 (standard script)" which was known as "今隸(current clerical script)" in Tang dynasty. Note also, 㯼 is 隸 as seen in *Annotations on Shuowen Jiezi* 《說文解字注》.

(9). 而逸少兼之 – "兼" means "同時涉及具有兩件或兩件以上的行為或事物(doing two or more things at the same time)" in this context. It does not mean "combine" as suggested by Chang and Frankel (Chang and Frankel:2).
　　Note Zhang Zhi and Zhang Yao had also scribbed both standard and cusrsive scripts well, so their artistic beauties were not restricted to one particular scrupt. For futher

discussions, please see footnotes (70) and (71).

(10). 匪無乖互 – Entire phrase should be interpreted as "not without any mistake". "匪" means "不(not)", "無" means "without", and "乖互" means " 差錯(mistake)" in this context. This is a key phrase in which Sun Guoting was expressing his disagreement with the critics' overall evaluation of the Four Meritorious Calligraphers (see Line 14-15). He contended that Wang Xizhi was on par with Zhang Zhi and Zhong Yao while the critics suggested otherwise, and hence concluded that the critics' assessment were "not without mistake". This sentence does not mean "each have his shortcoming" as proposed by Chang and Frankel (Chang and Frankel:2) or "lacking of shortcomings" by De Laurentis (De Laurentis:43).

(11). 輒 – "輒" means "即 (immediately)".

(12). 不亦過乎- This sentence should be interpreted as "isn't that a mistake", not "went too far" (Chang and Frankel:2) or "certainly excessive" (De Laurentis:44). This is a common phrase seen in classical Chinese literature, and an example of a correct translation of it can be seen in James Legge's *The Texts of Taoism* translating *The Writings of Chuang Tzu , Inner Chapters , The Seal of Virtue Complete* （《莊子 •內篇•德充符 》）:

> 今子之所取大者 , 先生也 , 而猶出言若是 , 不亦過乎 !
> There now is our teacher whom you have chosen to make you greater than you are; and when you still talk in this way, **are you not in error**?
> Source: 郭慶藩 《莊子集釋》冊一 .北京: 中華書局, 1985, pp.197-198.

(13). 且立身揚名, 事資尊顯 – "事資" means "this matter is relied upon" as seen in Du You's (杜佑) *Tongdian* (《通典》), *Volume 15, Examination and advancement III* :

事資訓誘, 不可因循。
<u>This matter is relied upon guidance from others</u>.
(interpreted by KS Vincent Poon)

and *Volume 28, Government offices X*:

高祖以天下未定, <u>事資武力</u>。將舉關中之眾, 以臨四方。
<u>This matter is relied upon military power</u>.
(interpreted by KS Vincent Poon)

Source: 杜佑《通典》卷十五, 選舉三, p. 3b. 卷廿八職官十, p. 4a. 光緒丙申年四月浙江書局刊.

Hence, the entire sentence should be interpreted as "conducting oneself properly in society (立身) and hence establishing one's fame are, fundamentally, relied upon honoring and glorifying one's parents", not "establishing oneself and enhancing one's reputation serve to reflect honor one's parents" (Chang and Frankel:2) or "establishing one's person and elevating one's fame aims at providing notoriousness to one's parents"(De Laurentis:44). In addition, the usage of "notoriousness" in this context by De Laurentis is extremely questionable, as "notoriousness" is usually used to describe infamy but not fame of a more favorable nature.

Note that Sun Guoting's assertion here differs from, but is still consistent with, what is written in *The Classic of Filial Piety* (《孝經》) where it stated:

立身行道, 揚名於後世, 以顯父母, 孝之終也。
When we have established our character by the practice of

the (filial) course, so as to make our name famous in future ages and thereby glorify our parents, this is the end (ultimate goal) of filial piety. – translated by James Legge in *Sacred Books of the East.*

Sun Guoting merely pointed out the reverse is also true: in order for one to establish one's fame and moral character, one must first honor one's parents. This is consistent with the system of nominations to public office for "Being Uncorrupted and A Role Model of Filial Piety" (察舉孝廉) in Han Dynasty. For more examples, please see *Cao Quan Stele* (曹全碑) in KS Vincent Poon and Kwok Kin Poon's *English Translation of Classical Chinese Calligraphy Masterpieces* 英譯法書 (Toronto: The Senseis, 2019).

(14). 勝母之里，曾參不入 – Extracted from *Dong Guan Han Ji* (《東觀漢記・傳十一・鍾離意 》).

(15). 況乃假託神仙 – "假託" should be interpreted as "as a pretext of", not "falsely claimed"(Chang and Frankel:2) or "falsely entrusted" (De Laurentis:44) . The history of Wang Xianzhi's using the powers of celestial beings as a pretext for his excellent calligraphy is recorded in one of Wang Xianzhi's own writings, *Fei Niao Tie* (《飛鳥帖》):

臣年二十四, 隱林下有飛鳥左手持乐, 右手持筆, 惠臣五百七十九字。臣未經一周, 形勢骹骼。

(16). 面墙 – "面墙(a person facing a wall)" is a metaphor for an ignorant, visionless and uneducated person, and is explained in *The Classic of History, Officers of Zhou, Annotated by Kong Yingda* (《尚書・周官》 孔穎達 疏):

人而不學，如面向牆，無所睹見。
If one does not study and learn, it is as if one is facing a wall

and so cannot see what is in front of him/her.
(translated by KS Vincent Poon)

(17). 志學之年 – This refers to the age of around fifteen as noted in *The Confucian Analects - Wei Zhang* (《論語·為政》) :

> 「子曰：吾十有五而志於學。」
> The Master said, "At fifteen, I had my mind bent on learning."
> – translated by James Legge in *The Chinese Classics*.

(18). 味鍾張之餘烈 – In this context, 味 refers to "研究 (research)", not "savored" as suggested by Chang and Frankel (Chang and Frankel:3) or "tasting" by De Laurentis (De Laurentis:45).

(19). 挹羲獻之前規 - 挹 here means "舀取(take and follow)".

(20). 時逾二紀 - 紀 means "twelve years". Hence, "二紀" means two twelve years which is twenty-four years in total.

(21). 有乖入木之術 - "乖" in this context means "違背 (going against/disloyal)". "乖" does not carry the meaning of "failed to reach" as suggested by Chang and Frankel (Chang and Frankel:3), or "lacking" by De Laurentis (De Laurentis: 45).

In this context, "入木(to make the ink permeate deeply into the wood)" is used to describe the ability to write extraordinary good calligraphy. There is a Chinese idiom "入木三分" wherein it described a rumor that renowned calligrapher Wang Xizhi was able to produce brushstrokes so powerful that the ink could permeate into the wood by "three tenths" of a Chinese inch.

(22). 觀夫懸針垂露之異 – "異" should most likely mean "不平常,特別 (unusual, distinctive or exceptional)", not necessarily "differences" as suggested by Chang and Frankel (Chang and Frankel:3). The last character in this sentence,"異", is used as an adjective for "懸針垂露", just like "奇" is used as an adjective for "奔雷墜石" in the subsequent sentence (Line 36).

(23,24).

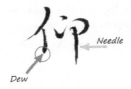

Source: KS Vincent Poon's *A Model of Lanting Xu.*

(25). 鴻飛獸駭之資 –"資" means "放縱(unrestraint)" and "天性(nature)" in this context.

(26). 臨危據槁之形 – In this context, "臨" means "面對(to face)", "危" means "將死(about to die)", "據" means "處於(in a state of)", and "槁" means "死(death)". Hence, "臨危據槁" should be interpreted as "facing near-death or in a state of death". This sentence is used to describe that brushstrokes can be extremely frail and thin.

(27). 或重若崩雲 – In this context ,"崩" means "厚(thick)".

(28). 纖纖乎似初月之出天崖 – "崖" means "邊際(border or edge)". Hence, "天崖" means "the edge of the skies" which refers to the horizon.

(29). Note that in lines 35-43, Sun Guoting was describing various artistic aspects of calligraphy: the appearances of brushstrokes (lines 35-40), the movements of the brush (line 41-42) as well as the spatial arrangements within brushstrokes of a character, or even between each character (line 43). Some of these metaphors can be found in earlier literatures such as Wei Shuo's *Bizhentu* (衛鑠《筆陣圖》) and Xiao Yan's *Caoshuzhuang* (蕭衍《草書狀》).

(30). 變起伏於峯杪 – "峯" can mean "peak or tip" while "杪" can mean "微小 (small)". Collectively, this refers to the fine tip of a brush in this context.

(31). 殊衄挫於毫芒 – "衄挫" refers to the specific "衄筆" and "挫筆" calligraphic techniques in utilizing the brush as described in 《中國書法大辭典》:

衄鋒: 用筆法之一。謂筆既下行又往上。然又與回鋒有別,回鋒用轉, 衄鋒用逆。

挫鋒: 用筆法之一,又稱「挫筆」。指運筆時突然停止,以改變方向的動 作。

Source: 梁披雲 , 《中國書法大辭典》.廣東: 廣東人民出版社 , 1991 , p.92.

(32). In the *Book of the Later Han, Volume 47, Biographies of Ban and Liang*, Ban Chao (班超) was recorded to have once said:

「大丈夫無它志略 ,猶當效傅介子、張騫立功異域 ,以取封侯 ,安能久事筆研閒乎?」
If a man has no other ambitions and abilities, he should, at the very least, follow the examples of Fu Jiezi and Zhang Qian to establish one's fame and titles by conquering the

frontiers; as such, how can a man spend a great deal of time in occupying himself in calligraphy?
(interpreted by KS Vincent Poon)
Source: 范曄《後漢書》卷四十七班梁列傳. 香港:中華書局，1971，p.1571.

(33). In Sima Qian's *Records of the Grand Historian, Volume 7, Annals of Xiang Yu*, Xiang Ji (Yu) was recorded to have once said:

「書足以記名姓而已，劍一人敵，不足學，學萬人敵。」
All scribes do is make lists of names, and swordsmen can only fight a single foe: that is not worth learning. I want to learn how to fight ten thousand foes. - translated by Xianyi Yang and Gladys Yang.
Source: 司馬遷《史記》卷七項羽本紀. 香港: 廣智書局，出版年份缺，p.1.

(34). 況復溺思豪釐 – "況復" means "何況又(let alone additionally)", not "How much more" as suggested by Chang and Frankel (Chang and Frankel:4) or "All the more" by De Laurentis (De Laurentis:47).
　　"豪" is "毫", which means "long fine hair". In this context, "豪釐" refers to the fine and thin long hairs that comprise the brush pen and so should be interpreted as a metaphor for calligraphy.

(35). 樂志垂綸 – "垂綸" refers to "釣魚 (fishing)" but it also carries the meaning of "隱居(in recluse)". Hence, it is translated here as "fishing in solitude".

(36). 尚體行藏之趣 – "行藏" should be interpreted as "安於所遇 (at peace with whatever the circumstances)". The term is originally extracted from the words of Confucius, as seen in *The Analects - Shu Er* (《論語•述而》):

子謂顏淵曰：「用之則行，舍之則藏，唯我與爾有是夫！」
The Master said to Yan Yuan, "When called to office, to un-
dertake its duties; when not so called, to lie retired - it is only
I and you who have attained to this." – translated by James
Legge in *The Chinese Classics*.

Zhu Xi (朱熹) later annotated this "行藏" in his *Interlinear
Analysis of and Collected Annotations to the Four Books -
Annotations on The Analects* (《四書集註‧論語》):

行藏安於所遇…。
Whether "行(called to office)" or "藏(not so called to the
office)", one should be at peace with whatever the circum-
stances.
(translated by KS Vincent Poon)
Source: 朱熹《四書集註》，論語述而第七.香港: 太平書
局，1968，p.42.

Hence, it does not mean "practicing reclusion" as ob-
served in De Laurentis' translation (De Laurentis: 47) nor
"knowing when to be active and when to retire" by Chang
and Frankel (Chang and Frankel: 5).

(37, 38). 詎若功定禮樂 – "詎" means "哪知(who knew/
not many knew)" in this context. "若" means "其 (it)" which
refers to calligraphy. "定禮樂" means "revise the Rites and
Music" as noted in *Fengsu Tongyi – Qiongtong - Confucius*
(《風俗通義‧窮通‧孔子》):

(孔子) 自衛反魯，刪詩書，定禮樂，制春秋之義。

"定" means "審定, 訂正 (revise)".
Hence, "定禮樂" does not mean "records rites and
music" by Chang and Frankel (Chang and Frankel:5) nor

"spread rites and music" by De Laurentis (De Laurentis:47).

Note also that "禮樂制度(The system of Rites and Music)" is one of the most important social pillars in the traditional Chinese society and is the core of Confucianism. Here, Sun Guoting expressed his belief that calligraphy was a key element in supporting it.

(39, 40). 猶挺埴之罔窮- In this context, "挺埴" refers to "揉和黏土(hand-mixing wet clay)" in the production of pottery. It does not mean "sculpted clay figures" by Chang and Frankel (Chang and Frankel:5) nor "inestinguishable (indistinguishable?) moulding of clay" by De Laurentis (De Laurentis:47).

"罔窮"- means "無盡(infinite/no limit)".

(41). 與工鑪而並運- In this context, "與" means "相比(akin to)" not "and". "猶挺埴之罔窮" and "與工鑪而並運" are two couplet sentences: "猶" matches with "與", and so "與" is unlikely to represent a coordinating conjunction since "猶" is certainly not a coordinating conjunction. Hence, "與 (akin to)" matching with "猶 (as if/tantamount to)" seems to be more reasonable in interpreting these two phrases.

It is interesting to note that, due to the misinterpretation of the character "與" as "and", De Laurentis had merged these two couplet sentences into one: "that is also like the inestinguishable(indistinguishable?) moulding of clay simultaneously implemented with the art of the kiln!" (De Laurentis: 47).

"運" here means "遠(far and lasting)", see 中央研究院《搜詞尋字》. It was used here to describe the high durability of metallic crafts, which in turn served as metaphors for the long-lasting impacts of exemplary calligraphic works.

(42, 43). 得推移之奧賾 – "奧賾" means "精微 (profound and subtle) 義蘊 (implication)".

"推移" means "變遷、轉換(change)".

(44). 著述者假其糟粕 – "糟粕" means "造酒剩下的渣滓 (residues or dregs left over after the fermentation of wine)", and is usually used to describe the very bottom of a subject matter. In this context, this term should therefore be interpreted as the "dregs of calligraphy" since "其" refers to calligraphy. Moreover, "假" means "憑藉(rely on)" in this context. This important sentence and its subsequent sentences (Line 66-68) serve as a direct rebuttal to those who believe calligraphy is a useless pursuit (see Lines 56-57).

As such, Chang and Frankel's attempt in translating "假其糟粕" as "borrow the dreg of its wine" (Chang and Frankel:5) makes no sense, since calligraphy cannot produce or possess wine and such an interpretation does not follow the meaning of the entire paragraph.

Also, De Laurentis translated "著述者" as "Those who merely adhere to models" (De Laurentis:47) is puzzling, since "著述" carries no meaning of "modelling calligraphy (臨摹)" whatsoever.

(45). 藻鑒者挹其菁華 – In this context, "挹" refers to "舀取 (extract and obtain)". Therefore, in this sentence, it is not "distill" by Chang and Frankel (Chang and Frankel: 5) nor "dip into" by De Laurentis (De Laurentis:47).

(46). 固義理之會歸 – "義理" refers to "the principles of righteousness(微言大義之理)", which is a core value in Confucianism like "禮樂制度(The system of Rites and Music)". "會歸" means "會合,歸結 (culmination)".

Hence, it does not mean "an integration of reason" by

Chang and Frankel (Chang and Frankel:5) nor "knowledge and principles are joined together" by De Laurentis (De Laurentis:47).

(47). 信賢達之兼善者矣 – "賢達" means "賢能通達之人,有才德的人 (wise, talented and virtuous persons)". This sentence was written as a direct follow-up to the previous sentence "固義理之會歸": since calligraphy is a culmination of the principles of righteousness (義理之會歸), Sun Guoting argued, those who follow the principles of righteousness (ie. 賢達) should also be able to write good calligraphy (兼善).

Hence, the sentence should not be interpreted as "it is a sure bond linking all kinds of talented and intelligent men who excel in it" as observed in Chang and Frankel's translation (Chang and Frankel:5). Nowhere in the sentence did Sun Guoting imply that calligraphy can serve as a conduit or a bond to link the hearts and minds of those who are wise and intelligent.

(48). The families of Wang (王), Xie (謝), Xi (郗), and Yu (庾) were four renowned families that were known for raising many distinguished gentries and calligraphers during the Eastern Jin dynasty:

> 王、謝、郗、庾均為東晉大族。其子弟多身居高位，書法上亦
> 多有造詣。其中王家的王導、王羲之、王獻之，謝家的謝尚、
> 謝奕、謝安，郗家的郗愔，庾家的庾亮等都是書法名家。
> Source: 馬永強《書譜•書譜譯注》.鄭州市: 河南美術出版
> 社 , 1993 , p.68.

(49). 方復聞疑稱疑 – "稱" in this context refers to "頌揚 (praise)".

(50). 得末行末 – "末" in this context means "事物次要的、

非根本的一面 (trivial, not the fundamentals of a matter or issue)". It does not mean "the worst" as proposed by Chang and Frankel (Chang and Frankel:5).

(51). 緘祕已深 - "緘" means "包藏 (hide, conceal, to prevent from being seen)" in this context.

(52). 圖真不悟 – "圖" means "摹擬, 模仿 (to model or simulate)" in this context. It does not mean "plan to" as suggested by Chang and Frankel (Chang and Frankel:5).

Note that De Laurentis (De Laurentis:48) did not translate the word "圖" in this sentence. He merely translated the entire sentence as "unenlightened about the standard script", which is significantly far away from the original meaning.

(53). 粗傳隸法 – "隸" is "今隸(current clerical script)" which is "楷書 (standard script)". See footnote (8).

(54,55). 自閟通規 – In this context, "閟" means "宮門、寢門、冢門(the door of a palace, bedroom or tomb)". Hence, "自閟" should mean "shutting off the door to isolate oneself from the outside".

"通規" is "通則(general rule or principle)". It is not "other avenues" as indicated by Chang and Frankel (Chang and Frankel: 5).

(56). 加以趨變適時 – Due to damages and subsequent repairs by others to the original work, there is an ambiguity of the character located at the "變" position:

This is certainly not the original character written by Sun Guoting.

Some suggested that this might be the cursive character of "變(change)", "便(convenience)", or "吏(official/clerk)". Judging from the meaning of this and the subsequent sentences, "吏(official/clerk)" is unreasonable for two reasons. First, "趨吏(tendency/attracted to officials)" makes no sense. Second, Sun Guoting would have directly contradicted himself as he contended in the next sentence (Line 83) that standard script, not semi-cursive script, is the most preferable for writing important and solemn texts including official documents.

As a result, the sentence is unlikely to mean "When speed is essential for the occasion" (Chang and Frankel: 6) or "for the hurried clerk" (De Laurentis:48).

(57). 行書為要 – "要" means "符合(appropriate)" in this context.

(58). 題勒方畐 – Here, "題" refers to "書題(titling books or documents)", "勒" refers to "書寫(writing)/刊刻(inscribing)", "方" means "準則(rules/standards)", and "畐" is "幅" that carries the meaning of "界限(limits)". Taken together, the vernacular Chinese interpretation should be "書題書寫與碑石刊刻,準則有所規限" and is translated to English as such in Line 83. Since it is necessary for important and solemn documents to be neat, tidy and legible, writing them in standard script is then highly desirable.

Note that "方" matches with "適" in line 82, which is similar in usage to a phrase in 《長笛賦》 written by 馬融 in Han dynasty:

取予時適，去就有方。

"方" means "準則(rules/standards)" here as well, certainly not "square".

"題勒方畐" is therefore not "For inscribing or carving on a large square surface" as suggested by Chang and Frankel (Chang and Frankel:6) nor "for the writing and the inscription of square boards" by De Laurentis (De Laurentis:48).

(59,60). 草不兼真，殆於專謹; 真不通草，殊非翰札 - The main idea of this part (Lines 69 to 93) is to tell readers how to study calligraphy properly. Hence, the gist of Lines 84 to 85 is certainly not about instructing one to combine the standard and cursive scripts to create a new one; rather, Sun Guoting recommends learners to first master both standard and cursive scripts so that he/she can write both scripts artistically well, without changing the normal form (字形) of either scripts. Therefore, the two translations below are certainly not what Sun Guoting contended:

> "If cao does not contain an ingredient of zhen, it is too specialized and meticulous. If zhen does not contain some cao, it is not in epistolary style." (Chang and Frankel:6)

> "In case the cursive does not combine the standard, it is in danger of being monotonous, whereas if the standard does not link up the cursive, it is not calligraphy at all." (De Laurentis: 48)

(61, 62, 63). 使轉為情性 – "使" refers to "moving the brush" while "轉" means "turning the brush in concert" as dictated in《中國書法大辭典》:

> 「使」,指運筆。「轉」,指行筆的轉折呼應。

Source: 梁披雲 ，《中國書法大辭典》.廣東: 廣東人民出版
社 , 1991 , p.75.

Consequently, "使轉" is not "curving movement" as inter-
preted by Chang and Frankel (Chang and Frankel:6) nor
"pulls and rotation" by De Laurentis (De Laurentis: 48).

"情性" is a term in Chinese calligraphy that refers to "a
scribed Chinese character's vitality, manner and aesthetic
flavor" as defined in 《中國書法大辭典》:

情性: 指字的精神、氣勢、韻味等。
Source: 梁披雲 ，《中國書法大辭典》.廣東: 廣東人民出版
社 , 1991 , p.193.

(64). 迴互雖殊 – Here, "迴互" refers to "回環交錯,變化
(changes/dynamics)". Therefore, the sentence cannot be
translated to "Even though the relations are reversed" by
Chang and Frankel (Chang and Frankel: 6) nor "Mixing
them together, although different," by De Laurentis (De
Laurentis: 48) .

(65). 故亦傍通二篆 – "二篆" refers to the two seal scripts "
大篆(large seal script)" and "小篆(small seal script)":

二篆: 指「大篆」和「小篆」。
Source: 梁披雲 ，《中國書法大辭典》.廣東: 廣東人民出版
社 , 1991 , p.2.

Note that Sun Guoting recommends, in additional to be-
ing adept at writing the standard and cursive scripts, learn-
ers should also master writing the two seal scripts, cleri-
cal script, zhangcao, fei ba, etc.. Chang and Frankel had
mistakenly interpreted this and its subsequent sentences:
"Thus they (standard zhen and cursive cao scripts) are also
related to the greater and lesser zhuan (seal scripts) and

involved with ba fen (clerical script)…" (Chang and Frankel:6)

(66). 俯貫八分 – "八分(ba-fen)" is clerical script (隸書) or Han clerical script (漢隸):

八分: 隸書一體,亦稱「分隸」、「分書」。其名始於魏、晉。
清劉熙載《藝概》卷五《書概》:「未有正書以前,「八分」但
名為隸; 既有正書以後, 隸不得不名「八分」。名「八分」者,以
別於今隸也。」(按: "今隸" 即 "正書"、"真書" 或 "楷書"。)
Source: 梁披雲 , 《中國書法大辭典》.廣東: 廣東人民出版
社 , 1991 , p.21.

(67). See 馬永強《書譜•書譜譯注》.鄭州市: 河南美術出版
社 , 1993 , p.70.

(68). 涵泳飛白 - "飛白(fei-ba)" is a calligraphic technique that produces black brushstrokes which have white spaces interspersed within them:

飛白: 一種特殊風格的書體,主要特徵是筆畫中夾白。宋黃伯思
《東觀 餘論》:「取其若絲髮處謂之白,其勢飛舉謂之飛。」
Source: 梁披雲 , 《中國書法大辭典》.廣東: 廣東人民出版
社 , 1991 , p.44.

Below is an illustration of a "飛白(fei-ba)" brushstroke:

Sample Brushstroke made by the fei-ba technique

Source: KS Vincent Poon's *A Model of Yan Zhenqing's A Poem on General Pei.*

(69). 若豪氂不察，則胡、越殊風者焉 – Here, "氂(thin long hair)" can be interpreted as "釐(fine and small)".

"胡、越" means the extreme North and South as "胡" and "越" represent the nomadic North and barbaric South of the Central Plain (中原) respectively. Note that "胡" and "越" were completely cut off from each other as the Central Plain stood right between them.

"風" refers to "風俗 (customs)".

As a whole, "若豪氂不察，則胡、越殊風者焉" is quite similar to the common Chinese maxim:

> 差若毫釐，繆以千里。
> A mistake, then, of a hair's breadth, will lead to an error of a thousand li (miles). – translated by James Legge in *Sacred Books of the East*.

Here, Sun Guoting concluded emphatically that if a learner does not observe the little fine details (outlined in Lines 80 to 92), then he/she will be on the opposite path towards success. Thus, the two translations below are baffling in interpreting this very important concluding remark:

> "But if there is the slightest error in differentiation, the two scripts (standard and cursive scripts) will be as far apart as Hu and Yue." (Chang and Frankel:6)

> "In case the slightest strokes are not examined, then there will be eccentric styles of the [barbarian people of] Hu and Yue." (De Laurentis:48-49)

(70). 伯英不真，而點畫狼藉 – "而點畫狼藉" should be a sentence that is written to address Zhang Zhi's standard script, not his renowned cursive script. This is for two reasons. First, Sun Guoting already acknowledged Zhang Zhi was the "Sage of the Cursive Script" in the previous sen-

tence (Line 94), so praising his cursive script here again is unnecessary and redundant. Second, it is likely that Sun Guoting wanted to point out Zhang Zhi wrote reasonably well standard script despite the fact that he was commonly known to have penned fantastic cursive script. The notion of Zhang Zhi having written standard script is supported by two independent sources:

I). The Xuanhe Calligraphy Catalogue , Volume 13, Han, Zhang Zhi (《宣和書譜•張芝》) :

(張芝)每作楷字，則曰: "匆匆,不暇草書。" 其精勤如此。故於草書尤工。

Whenever he (Zhang Zhi) wrote a standard script work, he always commented, "In a rush, did not find the time, leisure and mood to pen it in cursive script." This indicates his rigor and diligence towards the cursive script. Hence, he was especially adept at writing the cursive script.
(translated by KS Vincent Poon)
Source: 《宣和書譜》卷十三, 漢, 張芝.上海: 上海書畫出版社, 1984, p101. 房玄齡 《晉書》卷三十六衛瓘傳.北京:中華書局 , 1974 , p.1065.

The above passage can be interpreted to vernacular Chinese as:
(張芝) 每寫楷字，便說:「匆匆忙忙(按: 此即孫過庭所言「五乖」中之「心遽體留」) , 沒閑暇寫草書。」足見他對草書是這麼的嚴謹和盡心盡力。故此在草書方面，尤為擅長。
(Interpreted by Kwok Kin Poon)

II). In Judgements on Calligraphy (《書斷》) by Zhang Huai-guan (張懷瓘), Zhang Zhi's cursive scripts are categorized as masterpieces (神品) while his standard scripts are regarded as wonderful works (妙品). See 《歷代書法論文選》.上海: 上海書畫出版社, 1979, pp.171-173.

Thus, Zhang Zhi certainly had written good standard script, and, more importantly, he wrote his renowned cursive script only when he had the time, leisure and mood

(which suggested that writing good cursive script requires more focus and concentration, contrary to common belief). In addition, since Sun Guoting was much closer in time to Zhang Zhi's era than us, it is likely that Sun Guoting had once observed Zhang Zhi's standard script works in his lifetime.

Accordingly, the vernacular Chinese interpretation of "伯英不真，而點畫狼藉" should be:

> 伯英(張芝) 雖不專精楷書，但他楷書的點畫(上文所謂「真以點畫為形質」)，卻是奔放不拘。
>
> (interpreted by Kwok Kin Poon)

As such, the following translations of "伯英不真，而點畫狼藉" are completely incorrect:

> "Although Zhang Zhi did not do zhen, dots and lines can be seen everywhere in his calligraphy." (Chang and Frankel:6)

> "[Zhang]Boying did not write in the standard script, but his dots and strokes were scattered all over." (De Laurentis:49)

(71). 元常不草，使轉從橫- "使轉從橫" should refer to Zhong Yao's cursive script, not his standard script. Sun Guoting wanted to point out that Zhong Yao wrote reasonably well cursive script despite he was well known for his standard script. This is supported by two independent sources:

> I). In《中國書法大辭典》, Zhong Yao was known to "write various scripts well (兼善各體)"(see梁披雲《中國書法大辭典》.廣東: 廣東人民出版社，1991, p.274), and so it would not be surprising for Sun Guoting to argue that Zhong Yao had written fine cursive script by stating "使轉從橫".

> II). In *Judgements on Calligraphy* (《書斷》) by Zhang Huai-guan (張懷瓘), Zhong Yao's standard scripts are categorized

as masterpieces (神品) while his cursive scripts are regarded as wonderful works (妙品). See《歷代書法論文選》.上海: 上海書畫出版社, 1979, pp.171-173.

Hence, the vernacular Chinese interpretation of "元常不草，使轉從橫" should be:

元常(鍾繇)雖不專精草書，但他草書的使轉(上文所謂「(草以)使轉為形質」)，同亦奔放自如。
(interpreted by Kwok Kin Poon)

Note both "點畫狼藉" and "使轉從橫" were used to describe the physical forms (形質) of the standard and cursive scripts respectively (see Lines 86-87).

Accordingly, Sun Guoting reasonably argued that Zhang Zhi, the Cursive Script Sage, could still pen fine physical forms of standard script while Zhong Yao, the Standard Script Wizard, could still write good physical forms of cursive script. In other words, they wrote both scripts well (兼善), which is connected with the argument of the next sentence (see Line 96).

As such, the two translations of "元常不草，使轉從橫" are flawed:

"Zhong You did not write cao, curving movements abound in his pieces of writing." (Chang and Frankel:6)

"Yuanchang did not write in the cursive, but his pulls and rotations were everywhere." (De Laurentis:49)

(72). 自茲已降，不能兼善者，有所不逮，非專精也 - The vernacular Chinese interpretation of this entire sentence should be:

所以，自此之後，書家沒能兼善，有所不及，這不會是專精

的緣故。
(interpreted by Kwok Kin Poon)

(73). 雖篆、隸、草、章 - "隸" refers to the standard script (真書，即今隸).

(74). 工用多變 – "工用" refers to "techniques(工, 技巧) being applied(用, 使用)". It is not "uses /applications (功 用/用途)" that is commonly seen in English and vernacular Chinese interpretations. The usage of "uses/applications (功用/用途)" here is unreasonable for two reasons. First, how can designated "uses (功用)" be "dynamic/changed in a variety of ways (多變)"? Second, combining with the next sentence, how can the collections of these "uses(用途)" result in the beauties of the respective calligraphic scripts (濟成厥美)? It certainly does not make any sense to apply "uses/applications (功用/用途)" here. Thus, "工用多變" cannot be translated as "differ greatly in their uses" as sug- gested by Chang and Frankel (Chang and Frankel:6) .

(75). 濟成厥美 -"濟成" means "相助促成 (synergistically facilitate)" here.

(76). 然後凜之以風神- "風神" means "風采神情(artistic fla- vor and vigor)" as indicated in 《中國書法大辭典》:

> 風神: 風采神情。指書法藝術之氣韻。
> Source: 梁披雲，《中國書法大辭典》.廣東: 廣東人民出版
> 社，1991，p.192.

Therefore, it is not "elegant spirit" as proposed by Chang and Frankel (Chang and Frankel:6).

(77, 78). 驗燥濕之殊節- "燥濕" here refers to "世態炎涼

(the fickleness of the mundane world)" and has nothing to do with "dryness/moisture", while "殊節" means "高尚的節操 (noble integrity)". These are supported by two classical Chinese texts:

I. *Book of the Later Han, Volume 53, Biography of Shentu Pan* (申屠蟠):

不為燥濕輕重，不為窮達易節。("燥濕" - 李賢注: 《律歷志》，銅為物至精，不為燥濕寒暑變其節，不為風雨曝露改其形，介然有常，似於士君子之行。)
Source: 范曄《後漢書》卷五十三申屠蟠列傳. 香港:中華書局，1971，p.1751.

II. *Book of Jin*, Volume 58, Biography of Zhou Fang (周訪):

伏願聖朝追其志心，表其殊節。
Source: 房玄齡《晉書》卷五十八周訪列傳.北京:中華書局，1974，p.1585.

As such, Line 102 in vernacular Chinese should be:

證驗了世態炎涼之下，仍可堅守高尚節操，千古不變。
(interpreted by Kwok Kin Poon)

Consequently, the following English interpretations are completely erroneous:

"When we investigate the various stages of dryness and moisture, we find that they have been the same for a thousand year." (Chang and Frankel:6)

"In experiencing the different phases of dryness or wetness it has been like this for ages." (De Laurentis:49)

(79,80). 百齡俄頃- In this context, "百齡" means "一生/一輩

91

子(a lifetime)", while "俄頃" means "轉瞬間 (in an instant)".
Hence, Line 103 in vernacular Chinese should be:

體會了老年異於壯歲，書法韻味自亦不同(此下文所謂「人書俱
老」)，可瞬間便一輩子了(亦孔子謂「不知老之將至」)。
(interpreted by Kwok Kin Poon)

(81, 82). 有乖有合- "乖" means "違背,不協調 (disagree-
able)", while "合" means "符合(agreeable)".

(83, 84). 感惠徇知 – In this context, "感" represents "感受
(feels)", "惠" conveys "暢順(comfortable and unhindered)",
"徇" means "順從(obey/adhere to)", and "知" refers to "感覺
(feelings)".
　　Hence, "感惠徇知" in Line 107 should be interpreted in
vernacular Chinese as:

情感舒暢，能依從心中的感覺。
(interpreted by Kwok Kin Poon)

Thus, the following two translation of "感惠徇知" is
wholly incorrect:

"Having a feeling favorable to quick apprehension." (Chang
and Frankel:7)

"[Having] a responding intelligence and a swift wit." (De Lau-
rentis:49)

(85).時和氣潤 – "潤" should be interpreted as "滋潤 (nur-
turing)", not necessarily "濕潤(moist/moisture)" as seen in
other English and vernacular Chinese interpretations. Sun
Guoting was merely arguing good weather is an agreeable
condition for one to write calligraphy.

(86,87). 心遽體留 – "遽" here means "匆忙, 窘迫 (rushed/anxious)", while "留" means "徐, 緩滯 (sluggish/stagnant)".

(88). 意違勢屈 – "勢" represents "形勢(circumstances)", while "屈" refers to "屈從(acting against one's will)". "意違勢屈" should therefore be interpreted in vernacular Chinese as:

情意違悖，因形勢所迫而屈折。
(interpreted by Kwok Kin Poon)

Accordingly, it is incorrect to translate "意違勢屈" as "constricted energy" (Chang and Frankel: 7) or "energy crooked" (De Laurentis:50).

(89, 90). 情怠手闌 – "怠" refers to "疲倦(tired/exhausted)" and "闌" means "闌珊(uninspired/uninterested)" in this context. "闌" here is certainly not "blocked" as seen in De Laurentis' translation (De Laurentis:50).

(91). 得器不如得志 – "志" here means "心情(mood/mind-set)", not "志向(will)" as used by De Laurentis (De Laurentis: 50).

(92). 暢無不適 – "適" refers to "美好 (beautiful)" in this context. It is not "achieve" (Chang and Frankel: 7) nor "reach" (De Laurentis:50).

(93). 企學者希風敘妙 – "希風" means "仰慕其高雅風格 (admire their elegant styles)" here.

(94). 導將來之器識 – "器識" here is "器量與見識(magnanim-

ity and insight)".

(95, 96,97). 除繁去濫，覩迹明心者焉 – "繁" is "多(many)", "濫" means "質量低劣(inferior in quality)", "迹" is "法書寶迹 (the past exemplary calligraphic works)", and "明" is "澄明 (to enlighten and illuminate)". The proper vernacular Chinese interpretation of "覩迹明心者焉" should be:

觀賞前人法書寶迹，心也澄明起來哩!
(interpreted by Kwok Kin Poon)

Thus, "覩迹明心" is not "look at surviving examples and comprehend the heart of the matter" (Chang and Frankel: 7) nor "looking at the [written] marks one will understand [the content]"(De Laurentis: 50).

(98, 99). 代有《筆陣圖》七行 – "代" is used here in place of "世(Currently in our times)". Tang dynasty Emperor Taizong's name was "李世民", and so it was a taboo (諱) to write any character in his name explicitly during the Tang dynasty. Note that this "《筆陣圖》(*Bizhentu*)" is not the one by Wei Shuo (衛鑠).

(100). 中畫執筆三手 – "三" here may mean "多數或多次 (many or multiple times)" not necessary "three"，"手" does not mean "hand" in this context and should be interpreted as "手法(approaches)". Therefore, "Three pictures of hands" (Chang and Frankel:7) or "three hands holding a brush" (De Laurentis:50) cannot be applied to interpret this sentence.

(101). 至於諸家勢評 – "勢" refers to "筆勢 (manners displayed among brushstrokes)", such as 蔡邕 (Cai Yong) "九勢 (Nine Manners of The Brushstrokes)".

(102). 暨乎崔、杜以來，蕭、羊已往 – "以來" is "starting from" while "已往" means "before". Hence, the sentence refers to a period between "崔、杜" and "蕭、羊" and is translated as such in Line 128. The following translations therefore are completely incorrect:

"From Cui Yuan and Du Du on, from Xiao Ziyun and Yang Xin to the present." (Chang and Frankel:8)

"After Cui [Yuan] and Du [Du], and after Xiao [Ziyun] and Yang [Xin]." (De Laurentis:51)

(103). 時亦罕窺 -"時" means "善(good)"(see *Kangxi Dictionary*《康熙字典》. 上海:上海書店, 1985, p.541) not "time" in this context. Interpreting it to "time" makes very little sense; why would scholars had very little time to study these artifacts that were already preserved and kept? Furthermore, having too little "time" to appreciate them should not be a criterion for Sun Guoting to exclude them from mentioning (see Line 133) as they could be of exceptional quality.

To interpret this phrase as "can examine and appreciate them" (Chang and Frankel:8) or "this is but a rare sight" (De Laurentis: 51) is consequently incorrect.

(104). Line 133 was a concluding statement for Lines 128-133 which were written to describe some of the works created between 1st and 6th Century AD.

(105). 其有顯聞當代 – "當代" refers to the contemporary times of Sun Guoting's era; in this context, this period should be the 7th Century AD of the Late Sui and Early Tang dynasties (隋唐).

(106). 且六文之作 – "六文" is "六書 (The Six Fundamental Methods of Creating Chinese Characters)". It includes 象形(pictographs), 指事(simple ideographs by origin), 會意 (semantic compound ideographs), 形聲(phono-semantic compounds), 假借(rebus or phonetic loan characters) and 轉注 (derivative cognates). For further study, please see Gao Heng's (高亨)《文字形義學概論》(香港: 邵華文化服務社，翻印版, pp.2-3).

(107). 八體之興 – "八體 (Eight Scripts of Chinese Characters)" includes 大篆 (large seal script)，小篆 (small seal script)，刻符 (tally carving script)，蟲書(bird-worm seal script)，摹印(seal stamping script，署書(title script)，殳書 (weapons inscription script) and 隸書 (clerical script). For further details, please see Tang Lan's (唐蘭)《中國文字學》(上海: 開明書店，1949，pp.157-163).

(108). 既非所習 – "習" here means "熟悉(familiar)" not "習用 (use)". Hence, "since those [ancient scripts] are not practised" (De Laurentis: 52) is a wrong interpretation for this sentence.

(109). 龜鶴花英之類 – "英" refers to "英芝書(lingzhi script)". Lingzhi (英芝 or 靈芝) is a well-known herbal mushroom since ancient China. For details, please see Leung Pai Wan's (梁披雲)《中國書法大辭典》(廣東: 廣東人民出版社，1991，p.62).

(110, 111, 112). 乍圖真於率爾 – "乍" means "或者(perhaps)", "圖" means "摹擬/模仿 (modelling/simulating)" and "率爾" is "輕率(frivolous)".

(113). 或寫瑞於當年 – "瑞" refers to "吉祥(auspicious)" in

this context.

(114,115). 代傳義之《與子敬筆勢論》十章 – "代" is used here in place of "世(Currently in our times)". See footnote (98,99).

"與" here means "給予(given to/for)".

"筆勢" is a Chinese calligraphy term that describes the manners and styles of brushstrokes expressed by one's movement of a brush. For further discussions please see Leung Pai Wan's (梁披雲)《中國書法大辭典》(廣東: 廣東人民出版社 , 1991 , p.103). It is certainly not "Configurations of the Brush" as proposed by De Laurentis (De Laurentis:52).

(116). 翰櫝仍存-"櫝" means "匣子(box/casket)" while "翰" is "書信(letters)".

(117,118,119,120,121). 豈有貽謀令嗣 , 道叶義方 , 章則頓虧 – "道" here is "道德/道義 (good morals)" not "方法/技術 (methods/techniques). "叶" is "協(in harmony with/consistent with)","義方" means "正義的(the righteous) 定規(laws/ways)", "頓" signifies "捨棄(abandon)", and "虧" refers to "違背". In Line 145, Sun Guoting contended that Wang Xizhi, a man of moral integrity (see Line 144), would not have taught his son with ways that contradicted the established moral norms. Thus, Line 145 emphasized more on morals than calligraphic techniques, and so "道" should be interpreted as "道德/道義 (good morals)" not "方法/技術 (methods/techniques).

(122). 又云與張伯英同學 – "同學" means "同師受業(a person who had learned from the same teacher)" in classical Chinese. It does not necessarily mean "fellow student" or "a student in the same class". Therefore, it is flawed to in-

terpret "同學" as "companion" (De Laurentis: 53) or "fellow student"(Chang and Frankel:9).

(123). 必有晉人同號 – "必" here means "如果(if)".

(124,125). 非訓非經 – "訓" refers to "訓詁(Exegesis)" and "經" signifies "經學(Canon Studies)". Sun Guoting here wanted to point out that the *Treatise* was not written with the academic rigors seen in Exegesis and Canon Studies and so should be excluded here in his narrative. To interpret "經" as "Classics" is questionable, since it was obvious that the *Treatise* was not a Classic (經) like *Classic of Poetry* (《詩經》) or *Book of Documents* (《書經》); there was no need for Sun Guoting to state the obvious. Moreover, Sun Guoting later on included and elaborated on many Wang Xizhi's works, such as *Lanting Xu* (《蘭亭集序》) etc., none of which is a Classic.

(126,127). 粗可彷彿其狀，綱紀其辭 – "彷彿" here means "似乎、好像、近似(roughly)", "狀" means "情形(situation/general aspects)", and "辭" is "解說 (explications)". "辭" is not "principles" as indicated by Chang and Frankel (Chang and Frankel:9) nor "contents" by DeLaurentis (De Laurentis:53).

(128,129). 冀酌希夷，取會佳境 – "希夷" here refers to "玄妙(marvels)". "取" here means "得到 (realize/obtain)" and "會" here means "悟(become enlightened)" and so "取會" is "to come to a realization and become enlightened". Therefore, "取會佳境" is not "they can comprehend the sublime state" as seen in DeLauretis' translation (De Laurentis:53).

(130). 闕而未逮，請俟將來 - "闕" here means "乏(lacking/

left out)", while "未逮" means "不及詳述(not narrated)".

"闕" does not mean "shortcomings" nor "failed" in this context for two reasons. First, why would the confident Sun Guoting knowingly write something erroneous in this important narrative? Second, some (including many English and vernacular Chinese interpretations) contend that this is a self-effacing statement, but then why would Sun state so arrogantly that his mistakes can be only corrected in the future but not now (請俟將來)? Therefore, "闕而未逮" cannot be "Where I have failed and missed" (Chang and Frankel:9) nor "If there are shortcomings or something I have not been able to reach" (De Laurentis:53).

(131,132). 今撰執、使、用、轉之由– "由" here means "方式 (means and techniques)". "由, 式也", see *Kangxi Dictionary* (《康熙字典》).

"執、使、用、轉" are Chinese calligraphy terms used to describe the handling and movements of a brush. For further discussions, please see Leung Pai Wan's (梁披雲) 《中國書法大辭典》(廣東: 廣東人民出版社, 1991, p.75).

(133). 執謂深淺長短之類是也 – "深、淺、長、短" are Chinese calligraphy terms that refer to how one holds a brush. For further discussions, please see Leung Pai Wan's (梁披雲)《中國書法大辭典》(廣東: 廣東人民出版社, 1991, p.75).

(134). 用謂點畫向背之類是也 – "向背" is a Chinese calligraphy term describing the inward and outward facing brushstrokes. For further discussions, please see Leung Pai Wan's (梁披雲)《中國書法大辭典》(廣東: 廣東人民出版社, 1991, p.84).

(135). 方復會其數法 – "會其數法 (collect the various methods in holding and moving the brush)" is a concluding sentence for Lines 153 to 157, which involves how one holds and moves the brush (執、使、用、轉).

(136). 貴使文約理贍，迹顯心通 –"貴" means "重要(important/utmost)" and carries the meaning of "my utmost intention" in this context. It is certainly not "precious" as interpreted by De Laurentis (De Laurentis:53).

(137,138,139). 代多稱習- "代" is used here in place of "世 (currently in our times)"; see footnote (98,99). It is incorrect to interpret it as "every generation" (Chang and Frankel:10) or "throughout the ages" (De Laurentis: 53).
　　"習" here means "熟悉(familiar)", and "稱" refers to "頌揚 (praise)".

(140). 取立指歸 – "立" here means "成就(accomplished works)". Chang and Frankel along with De Laurentis neglected to translate "立" completely.

(141). 致使摹搨日廣 – "搨" means "用紙墨磨摸古碑帖 (printed via ink rubbings with paper on carved wood or stone)".

(142,143,144). 先後著名，多從散落 - The focus of discussion in Line 167 is the models and prints of Wang Xizhi's works, not other notable calligraphers. Therefore, "先後著名" means "the rankings among renowned models of Wang Xizhi's works"; "先後" can represent "rankings" in classical Chinese, an example can be seen in *Baopuzi - Inner Chapters-Mingben*《抱朴子•內篇•明本》:

　　或問儒道之先後。

When asked about the ranking between Confucianism and Taoism.
(translated by KS Vincent Poon)
Source: 葛洪《抱朴子》卷十內篇「明本」.上海: 商務印書館, 1936, p.169.

Similar usage of "先後" can be seen in Line 134.

"多從散落" means "mostly made in accordance to his long-lost handwritten originals". Interpreting "先後著名 , 多從散落" to a sentence like "Whereas most of the works of other famous calligraphers before and after Wang have been dispersed and diminished" (Chang and Frankel: 10) is incorrect since many works of other famous calligraphers before and after Wang Xizhi, such as Zhang Zhi (張芝), Zhong Yao (鍾繇) and particularly Wang Xianzhi (王獻之) and so on, have certainly also been retained as seen in *Chunhua Imperial Archive of Calligraphy Exemplars* 《淳化閣帖》.

(145). 歷代孤紹 , 非其效歟? - As noted in footnote (142, 143,144), Line 167 focuses on the models and prints of Wang Xizhi's works. Therefore, "其" refers to the extensive modelling and printing of Wang Xizhi's work, not Wang Xizhi himself as suggested in many English and vernacular Chinese interpretations.

The proper vernacular Chinese interpretation of the entire Line 167 should then be:

> 羲之法帖 , 因而摹搨日漸廣泛, 研習者年年增加。諸帖著名摹搨本, 或好或次, 大多依據已散失之羲之原作摹印而來。羲之書法歷代特別得以承傳, 不就是廣泛摹搨的功效麽?
> (interpreted by Kwok Kin Poon)

(146). 試言其由 – "由" means "創作歷程(artistic evolution)"

in this context. "由, 經也, 言所經從", see *Kangxi Dictionary* (《康熙字典》).

Numerous English and vernacular Chinese interpretations have indicated "由" as "原因/緣由(reason/cause)" due to their misinterpretations of Line 167. Please see footnote (142,143,144) and footnote (145) for further discussion.

Note also Line 168 is an introductory sentence for Lines 169 to 173, which outlines Wang Xizhi's artistic evolution by narrating his numerous masterpieces from early to late in his life.

(147). 止如 – "止" is "之" (古"止"與"之"通); "之" is "諸" (之, 猶諸也); both see 中央研究院搜詞尋字. Therefore, "止如" is "諸如(such as)".

(148). 代俗 -"代" is "世" (see footnote (98,99)), and so "代俗" is "世俗(the society/public in our times)". It is therefore inaccurate to interpret it as "through the ages"(Chang and Frankel:10) nor "epochs" (De Laurentis:54).

(149). 《黃庭經》則怡懌虛無 – "虛無(nothingness)" is a special term in Taoist philosophy that describes the marvels of "無為(inaction)" as outlined in the *Book of Han, Volume 62, Biography of Sima Qian* (《漢書‧司馬遷傳》):

> 道家無為，又曰無不為。其實易行，其辭難知。其術以虛無為本，以因循為用。
> Source: 班固《漢書》卷六十二司馬遷傳. 香港:中華書局，1970，p.2713.

(150). 《太師箴》又縱橫爭折 – "爭折" is a phrase that expresses one's ambition to climb to the top in public office as indicated in a sentence in the poem《早春游樊川野居卻

寄李端校書兼呈崔峒補闕司空曙主簿耿湋拾遺》written by Tang dynasty poet Lu Lun(盧綸):

桂樹曾<u>爭折</u>,龍門幾共登。

折 refers to "折桂", which means "to become the top examinee in the public official exams".

Therefore, the proper vernacular Chinese interpretation of "《太師箴》又縱橫爭折" should be:

《太師箴》又縱橫奔放,望在功名上爭取折桂(第一)。(《太師箴》表露了他的心迹,功業上冀有所作為。)
(interpreted by Kwok Kin Poon)

Accordingly, "爭折" is not "conflicting views" (Chang and Frankel:10) nor "combative" (De Laurentis: 54).

(151). Line 173 refers to *The Statement of Pledge* 《告誓文》 mentioned in Line 169 and serves as a concluding sentence for Lines 169 to 173.

(152). 所謂涉樂方咲，言哀已歎-This sentence alludes to a phrase in *Rhapsody on Literature* (《文賦》) written by Jin dynasty's Lu Ji (陸機) :

思涉樂其必笑，方言哀而已嘆。

(153). 豈惟駐想流波，將貽嘽嗳之奏 – Line 175 alludes to an ancient story regarding the legendary musician Bo Ya (伯牙) who once encountered Zhong Zi Qi (鍾子期), an audience who could truly appreciate and comprehend Bo Ya's music. After Zhong's death, Bo Ya was extremely saddened and vowed not to play his music that was as beautiful as high mountains and running rivers (高山流水)

ever again.

(154). 馳神睢渙，方思藻繪之文 – The districts of Sui (睢) and Huan (渙) rivers were renowned for producing colorful tapestry and were said to inspire one to create outstanding literature if one were to observe the colorful hand-weaved patterns made at those places.

(155,156,157). 雖其目擊道存, 尚或心迷義舛 – "目擊道存" refers to a phrase in *Zhuangzi - Outer Chapters - Tian Zi-fang* (《莊子•外篇•田子方》) :

> 仲尼曰：「若夫人者，目擊而道存矣，亦不可以容聲矣。」
> Zhongni replied, 'As soon as my eyes lighted on that man, the Dao in him was apparent. The situation did not admit of a word being spoken.' - translated by James Legge in *The Texts of Taoism.*

Hence, "目擊道存" conveys the meaning of "being able to immediately comprehend simply by glimpsing without the usage of words".

"心迷" means "confused/baffled in one's mind", while "義" conveys the meaning of "正確的道理 (the right fundamental principles)" in this context.

This sentence described students of calligraphy, not Wang Xizhi. Thus, Chang and Frankel was extremely flawed in interpreting it as:

> Although he (Wang Xizhi) could clarify a matter at first glance, still his mind sometimes went astray and he made mistake.
> (Chang and Frankel: 11)

(158). 莫不強名為體 – "體" means "準則字體 (standard set font)" in this context, as indicated in 劉昫《舊唐書》:

徵曰：「褚遂良下筆遒勁，甚得王逸少體。」

(Wei) Zheng replied, "Chu Suiliang scribes with vigor and vitality, he more or less grasps the ability to scribe in the Wang Yishao (Wang Xizhi) <u>font</u>."

(interpreted by KS Vincent Poon)

Source: 劉昫《舊唐書》卷八十褚遂良傳. 臺灣: 臺灣中華書局, 1971, 冊六 p.1.

In Lines 177 to 180, Sun Guoting contended that it is incorrect to study calligraphy by classifying particular styles of renowned calligraphers, such as those of Wang Xizhi's, as a "standard set font" that one must adhere to in order to write good calligraphy. Rather, one should write without restraint along with one's emotions so as to create one's masterpieces. For further discussion on this "體", please see footnote (161,162).

(159). 共習分區 – "區" means "類". "區, 猶類也", see *Kangxi Dictionary* (《康熙字典》). Therefore, "分區" means "分類 (classification)".

(160). 風騷 – "風騷" alludes to two Chinese classics: *Airs of the States* (《國風》) and *Sorrow after Departure* (《離騷》). "風騷" collectively means the style of elegant literature written with unadorned passion.

(161,162). 原夫所致 ，安有體哉 – "原" here means "推究 (examining)", "夫" is "這 (this)", and "所致" means "所得到的 (obtained from)".

Many English and vernacular Chinese interpretations have incorrectly interpreted "體" here as "書體(writing scripts/styles)". De Laurentis, for instance, took "安有體哉" as "is it not absurd to think that the writing scripts might have determined [calligraphic works]?"(De Laurentis:55).

This sort of interpretation is flawed since Sun Guoting, in Lines 82 to 89, had acknowledged the important distinctions and uses among the different scripts in calligraphy.

Therefore, the proper Chinese vernacular Chinese interpretation of Lines 178-180 should be:

「哪知情感一動, 發為言辭, 自然便取集《國風》《離騷》的情意; 見晴而舒暢, 遇陰而愁鬱, 全亦來自天地自然的本性。[故此, 若把貴乎自然的書法勉強稱個標準字體,] 既失書道自然之情,道理上亦違天性自然之實。推究書道本源, 所得的是, 哪有什麼標準字體的啊?! 」

(interpreted by Kwok Kin Poon)

(163,164). 規模所設 – "規模" here means "格局(setup/layout)". In Chinese calligraphy, this refers to character structures and overall layouts (布局) such as the arrangements of black and white spaces within a character, between characters, and among rows of characters (分行布白, 計白當黑). For further discussions, please see Leung Pai Wan's (梁披雲)《中國書法大辭典》(廣東: 廣東人民出版社, 1991, p.170).

It is incorrect to interpret "規模" here as "norms" (Chang and Frankel:11) nor "rules" (De Laurentis:55) since subsequent lines focus on the discussion of character structures and overall layouts in calligraphy.

"設" means "陳列/安置(arrangement/organization)" in this context.

(165). 信屬目前 – "目前" means "現在(at this instant)". In this context, it should be interpreted as "at the instant of penning calligraphy".

(166). 規矩闇於胸襟 – "闇" is "諳(familiar/acquainted)" here, see *Dictionary of Chinese Character Variants* (《異體字字典》).

(167). 自然容與徘徊 – "容與" here means "安閒自得(at ease and satisfied)" while "徘徊" means "安行貌(the appearance of serenity)". The phrase is derived from 班固《西都賦》:

大輅鳴鑾, <u>容與徘徊</u> 。

(168,169). 蕭灑流落 – In this context, "蕭灑" means "灑脫, 不拘束(dashing and carefree)", "流" is "移動/流利(dynamic)", and so "流落" is a metaphor for one's meridians (經絡) are unblocked and circulating without any impediment

(170). 亦猶弘羊之心 – "弘羊之心" refers to the great mind of the renowned Han dynasty Imperial Secretary Sang Hongyang (桑弘羊, 152-80BC). He was known for planning and calculating as dictated in the *Book of Han - Biography of Ni Kuan* (《漢書•兒寬傳贊》):

運籌則桑弘羊。
Source: 班固《漢書》卷五十八兒寬傳.香港:中華書局 , 1970 , p.2634.

(171). 庖丁之目 , 不見全牛 – This sentence refers to a story in *Zhuangzi - Inner Chapters - Nourishing the Lord of Life* (《莊子•內篇•養生主》). The story narrated an extraordinary cook who could easily cut and dissect a cow into pieces without blunting his knife as he was able to visualize and cut along the "natural lines" to avoid the bones and ligaments. For further details, please see the English translation of *Zhuangzi* (《莊子》) by James Legge in *The Texts of Taoism*.

　　"庖丁" refers to "a person who works as a cook", absolutely not "Cook Ding" (Chang and Frankel:11) nor "Pao

Ding"(De Laurentis:56). "庖" means "a cook" and "丁" is "從事某種勞動的人(a person whose work involves some sort of labour)". To interpret "庖丁" as a cook known as Ding or a person whose name is Pao Ding is therefore utterly ridiculous.

(172). 言忘意得 – "意得" here means "grasped (得) the main essential idea (意)", whereas "言忘" means "words that can be left forgotten". Note, "言忘(words that can be left forgotten)" resonates with Line 150 "夫心之所達，不易盡於名言(Alas, what is understood in the mind can be difficult to express completely in words)".

(173). 斷可極於所詣矣 – "斷" here means "一定(surely)", "極" means "達至(reach)", "所詣" means "所在(where it resides)". The term "所詣" means "所在", and this is best supported by the following classical Chinese passage in Song dynasty's *Imperial Readings of the Taiping Era* (《太平御覽》):

> 又曰姚興死之前歲，太史奏熒惑在瓠瓜星中，一夜忽然亡失，不知所在。或謂下入危亡之國，將為童謠訛言之，妖而後行其災禍。太宗聞之大驚，乃召碩儒十數人，令與史官求其所詣。
> (求其所詣 means "to ask where it now resides".)
> Source: 《太平御覽》卷七百三十三, 方術部十四「占星」,p3a. 嘉慶十二年歙鮑氏校宋版.

Since the focus here is the art of calligraphy, the term "所詣" should be read as "where the art of calligraphy resides". Sun Guoting was merely pointing out that learning character structures and overall layouts properly is one of the means to arrive at the core of the art . Hence, the proper vernacular Chinese interpretation of "縱未窮於眾術，斷可極於所詣矣" should be:

縱使未曾究盡各種技法 ，亦必可最終達至[書道之]所在了 。
(interpreted by Kwok Kin Poon)

"詣" should not be interpreted as "造詣(aims/achieve-ments)"; it is most unreasonable to claim that one could ac-complish "peak of their aims" (De Laurentis: 56) nor "their goal" (Chang and Frankel:11) by just studying Sun Guot-ing's "rough outlines (粗舉綱要, Line 188)".
(174). 若思通楷則 – "楷則" is "典範(exemplars)" in this context.

(175,176,177,178). 抑有三時 ，時然一變 ，極其分矣 – "抑" here means "或者(perhaps)", "三時" is "三階段(three stages)", whereas "然" is "成/形成(forms/brings about)". The term "三時" representing "three stages" can be seen in the classical Chinese text *Notes and Commentaries of the Analects of Confucius - Xue Er* (《論語注疏•學而》):

凡學有三時。
all learning has three stages.
(translated by KS Vincent Poon)

"分" here means "天分/資質(inherent talent/potential)". Hence, the proper vernacular Chinese interpretation of "勉之不已 ，抑有三時 ，時然一變 ，極其分矣" should be:

不停的努力學習書法 ，其中或有三個階段 ，每階段總會帶來一些很大的變化 ，那可要盡自己的天分了 。
(interpreted by Kwok Kin Poon)

As such, interpreting "時然一變 ，極其分矣" to "Each stage to the next as its potential is exhausted" (Chang and Frankel:12) or "Each period requires a change once its

apex is reached" is incorrect.

(179). 至如初學分布 – "分布" means "布局(character struc-tures and overall layouts)". For further discussions, please see footnote (163,164).

(180). 但求平正 – "平正" in Chinese calligraphy means "四平八穩 (proper, neat and balanced)" and is often used as an adjective to describe one's calligraphy.

(181). 務追險絕 – "險絕" in this context means "極險絕妙 (risky and extraordinary)" and is used here as a sharp con-trast to "平正(proper, neat and balanced)" in Line 195.

(182). 後乃通會 – "通會" in this context means "貫通融會 (thoroughly comprehend and abe to harmonize)".

(183). 通會之際，人書俱老 – This particular sentence reso-nates with Line 103 : "體老壯之異時，百齡俄頃(by the time one experiences and comprehends the distinct differences of the artistic flavors exhibited between the older and the younger self, a lifetime has already passed in an instant)".

(184). 仲尼云：「五十知命。七十從心。」 - This sentence refers to a passage in *The Analects - Wei Zheng* (《論語•為政》):

> 子曰：「吾十有五而志于學，三十而立，四十而不惑，五十而知天命，六十而耳順，七十而從心所欲，不踰矩。」
> The Master said, "At fifteen, I had my mind bent on learning. At thirty, I stood firm. At forty, I had no doubts. At fifty, I knew the decrees of Heaven. At sixty, my ear was an obedient organ for the reception of truth. At seventy, I could follow what my heart desired, without transgressing what was right."
> – translated by James Legge in *The Chinese Classics*.

(185). 故以達夷險之情 – "夷" is "平", therefore "夷險" is "平險", which in turns refers to "平正" and "險絕" in Lines 195 to 197.

(186). 體權變之道 – "權變" means "靈活應付隨時變化的情況 (being flexible in dealing with an ever-changing circumstance)".

(187). 時然後言 – This phrase is from *The Analects – Xian Wen* (《論語•憲問》):

> 夫子時然後言。
> My master speaks when it is the time to speak - translated
> by James Legge in *The Chinese Classics*.

(188,189). 而風規自遠– "風規" in this context is "文藝作品的風格(artistic fashion)", "遠" refers to "高遠 (grand and noble)". Therefore, the proper vernacular Chinese interpretation of "而風規自遠" is:

> 而風格自然便是高遠。
> (interpreted by Kwok Kin Poon)

It is certainly not "[thus making] his style unachievable [by other calligrapher]" (De Laurentis: 56) nor "because his personality was controlled and far-reaching" (Chang and Frankel: 12).

(190,191). 莫不鼓努為力 – "鼓努" here is "exerting one's greatest might in penning the vertical brushstroke"; "努" in Chinese calligraphy refers to penning the vertical stroke as indicated in Leung Pai Wan's (梁披雲)《中國書法大辭典》(廣東: 廣東人民出版社 , 1991 , p.107).

Pictorially, "努" is:

The vertical brushstroke
"努"

Source: 潘國鍵宗哲書法講座, http://poonkwokkin.com/
Calligraphy_Video/Call_V_4.html .

As such, "力" is "筆力(strength in applying the brush)" .
"莫不鼓努為力, 標置成體" can therefore be interpreted in
vernacular Chinese as:

無不奮力寫那「豎直」以為筆力，標榜自己學成了某一家的字
體 。
(interpreted by Kwok Kin Poon)

Note also "標置成體" does not refer to individuals de-
veloping distinguished fonts on their own, as suggested in
many English and vernacular Chinese interpretations; the
main idea of this phrase is to describe all learners (莫不)
were trying to accomplish (成) to write in an established
"set standard font"(字體) of a renowned calligrapher (eg.
in a font scribed by Wang Xizhi's). This phrase resonates
with Line 177's "莫不強名為體(they are all compelled to
classify prominent calligraphers' handwritings as various
"standard set fonts")".

Accordingly, the following interpretations of "莫不鼓努為
力, 標置成體" are incorrect:

"calligraphers have strained too hard and used affectations to
form a personal style." (Chang and Frankel:12)

"everyone has tried hard [to show] vigor, establishing models and creating forms artificially."(De Laurentis:56)

(192,193). 豈獨工用不侔 – "工用" here means "力氣(effort)" as indicated in the poem 《晚燕》 composed by Tang dynasty poet Bai Juyi (白居易) :

不悟時節晚，徒施工用多。
Not realizing the times were too late, all that much effort had gone to waste.
(translated by KS Vincent Poon)

"侔" means "配(match/in accord)" as suggest in *Zhuang-zi - Inner Chapters - The Great and Most Honoured Master* (《莊子•內篇•大宗師》) :

畸人者，畸於人而<u>侔</u>於天。
He stands aloof from other men, but he is <u>in accord</u> with Heaven. - translated by James Legge in *The Texts of Taoism.*

Therefore, the vernacular Chinese interpretation of "豈獨工用不侔" should be:

何止所費力氣[與效果]不相配。
(interpreted by Kwok Kin Poon)

As such, "豈獨工用不侔，亦乃神情懸隔者也" should not be interpreted as "How is it then possible that only technique and application are not the same[from the past]: spirit and expressiveness also are very different!" (De Laurentis:57)

(194,195,196). 自矜者將窮性域，絕於誘進之途 – "窮" here means "止絕(insulate)", "性域" refers to "性情境界(the

realm of emotions)", "誘進" is "誘導進取(directed improvement)". As such, the proper vernacular Chinese interpretation should be:

> 自滿自誇的人，將會自絕於[書法] 情性的境域，亦 斷絕了循循
> 善誘得而上進的道路 。
> (interpreted by Kwok Kin Poon)

Thus, to interpret "將窮性域" as "reach a limit" (Chang and Frankel:12) is completely incorrect.

(197,198,199,200). 自鄙者尚屈情涯, 必有可通之理 – Here, "尚" means "庶幾/差不多(almost)", 屈 is "斷絕(completely disconnected)", and "情涯" represents "shores of emotions". "涯" takes the meaning of "banks/shores" as suggested in *The Book of Documents - Shang Shu - Count of Wei* (《尚書•商書•微子》):

> 若涉大水 ，其無津涯。
> its condition is like that of one crossing a stream, who can find
> neither ford nor bank. - translated by James Legge in *The
> Chinese Classics*.

Also, "理" in this sentence should be interpreted as "道 (principle)".

Together, the entire sentence should then be interpreted in vernacular Chinese as:

> 自覺鄙陋不足的人 ，雖差不多也隔斷了情性的邊岸，卻仍必有
> 可以通達的道理。
> (interpreted by Kwok Kin Poon)

"尚屈情涯" is therefore not "inhibited" (Chang and Frankel:12) nor "have frustrated emotions" (De Laurentis:57).

(201). 蓋有學而不能 – "能" here means "善也/勝任(good at/master)", see *Kangxi Dictionary* (《康熙字典》).

(202). 考之即事 – "即事" means "面對眼前事物(with regards to the current matter at hand)". Therefore, "考之即事" in this context should be interpreted in vernacular Chinese as:

探索一下眼前所討論的書法這事情 。
(interpreted by Kwok Kin Poon)

(203). 然消息多方 – "消息" here means "變化(variations)".

(204). 乍剛柔以合體 – In this instance, "體" refers to "字的形體 (body of a character)". This should be distinguished from the "體" in Lines 177 and 206, which refers to "字體 (fonts)". Furthermore, it is not "書體(scripts)" and is certainly not "style" as interpreted by Chang and Frankel (Chang and Frankel:12) .

(205,206). 忽勞逸而分驅 – "勞逸" is "勞苦與安逸(labor and serenity)" and was used here by Sun Guoting as a metaphor for "重筆與輕筆(heavy and light brushstrokes)". For further discussions on light and heavy brushstrokes, please see Leung Pai Wan's (梁披雲) 《中國書法大辭典》 (廣東: 廣東人民出版社 ， 1991 ， p.96).
　　"驅" means "快跑(running quickly)", hence "分驅" should mean "running quickly in different directions". Note also many misread the cursive "驅" in the original calligraphy as "軀(body)".
　　It is therefore wholly incorrect to interpret "忽勞逸而分驅" as "underrate the [modulations] of labour and rest, and differentiate themselves accordingly" (De Laurentis:56).

(207,208). 或恬憺雍容 - "恬憺" means "清靜淡泊(tranquil

and plain)", whereas "雍容" means "儀態溫文大方(gentle and graceful)".

(209,210). 內涵筋骨- "筋(Tendons)" in Chinese calligraphy means "筆鋒的「藏」和「度」(the aesthetic manner of power buried within a brushstroke or among brushstrokes) ". 陳繹曾《翰林要訣•筋法》:

> 字之筋，筆鋒是也。斷處藏之，連處度之。藏者首尾蹲搶是
> 也；度者空中打勢，飛度筆意也。
> Source: 《歷代書法論文選》.上海: 上海書畫出版社, 1979,
> pp.482-483.

"骨(Bones)" in Chinese calligraphy refers to a brushstroke that is "剛勁有力,氣勢雄強(strong and powerful with an imposing and compelling manner)". For further discussions on "筋" and "骨", please see Leung Pai Wan's (梁披雲)《中國書法大辭典》(廣東: 廣東人民出版社,1991, p.98).

(211,212,213). 或折挫槎枿 – In Chinese calligraphy, "折挫" means "turns and twists" when penning corners within a character. For further discussions, please see Leung Pai Wan's (梁披雲)《中國書法大辭典》(廣東: 廣東人民出版社，1991， pp.92-93).
 "槎枿" means "樹的杈枝(twigs that branch out from a tree)".

(214). 外曜峯芒 – "峯芒" is "鋒芒", which is "字的棱角(sharp edges and corners of a character)" in Chinese calligraphy. For further discussions, please see Leung Pai Wan's (梁披雲)《中國書法大辭典》(廣東: 廣東人民出版社, 1991, p.98).

(215). 況擬不能似- "況" here means "情態 (instances)".
 Chang and Frankel had taken "況" here as "Yet", and so

their interpretations of this and its subsequent sentences were erroneous (Chang and Frankel:12).

(216). 分布猶疏 – In this context, "猶" means "太(very)", and "疎" is "疏", which means "不熟練(not proficient)". "疎" here is not "loose" as seen in both Chang and Frankel's (Chang and Frankel:12) as well as De Laurentis' (De Laurentis:56) interpretations.

(217). 躍泉之態 – "躍泉" is literally "leaping out of water streams" and is generally used to describe the movements of dragons. An example is the phrase "代邸東南龍躍泉" written by Tang dynasty poet Lu Huaishen (盧懷慎).
　　Note further "躍泉之態，未覩其妍" and the subsequent sentence "窺井之談，已聞其醜" are pairing sentences. Therefore, "其" in both sentences refer to the same object, which is the lousy student of calligraphy. To argue "其" in "未覩其妍" represents "龍(dragon)" (Chang and Frankel:12, De Laurentis:57-58) is therefore erroneous.
　　The proper vernacular Chinese interpretation of "躍泉之態，未覩其妍" should be:

> [寫出來的字]　，就算有龍躍於泉的形態　，也看不見它的妍美　。
> (interpreted by Kwok Kin Poon)

(218,219). 窺井之談, 已聞其醜 – "窺井" is "窺(looking into) 井(a well)" and is used in classical Chinese to describe unclarity and muddledness; "窺井" represents the inability to see one's eyes clearly when one stares down at the water reflection of oneself coming out from the bottom of a well. As *Huainanzi - Craft of the Ruler* (《淮南子‧主術訓》) by Liu An (劉安) indicated:

> 夫據幹而窺井底,雖達視猶不能見其睛。
> As one leans against the fence and stares into a well, despite

one can glimpse [the image reflected from the bottom of the well], one cannot see one's eyes clearly.
(translated by KS Vincent Poon)
Source: 劉文典《淮南鴻烈集解》, 冊三卷九, 主術訓.上海:商務 印書館, 1933, pp.20-21.

"已" here means "必然(certainly)".

Therefore, the proper vernacular Chinese interpretation of "窺井之談，已聞其醜" should be:

那些有如低頭望井水[永不能照見自己眼珠]的矇眛言談，定必 一聽而知其醜陋 。
(interpreted by Kwok Kin Poon)

From all of the above, it is clear that "窺井" has absolutely nothing to do with the well-known Chinese idiom "井底之蛙 (The toad looking up while sitting at the bottom of a well)" or "坐井觀天 (Sitting at the bottom of the well to observe the skies)", which Chang and Frankel as well as De Laurentis suggested (Chang and Frankel:12, De Laurentis:58); in fact, "窺井" means "looking at/down into a well" , which is directly opposite to "looking up from the bottom of a well".

(220,221,222). 縱欲搪突羲、獻，誣岡鍾、張, 安能掩當年 之目，杜將來之口 – "搪突" means "冒犯(offend)", whereas "誣岡" means "誣陷毀謗(slander)". Note this sentence applies to lousy learners of calligraphy as Lines 217-221 narrate Sun Guoting's opinions on them: Sun lamented that lousy learners of calligraphy (who does not examine the art in detail and model with close resemblance, Line 217) frequently claimed that they had faithfully studied and modelled the works of the renowned Xi, Xian, Zhong or Zhang, despite their works were actually inferior.

"口" here means "言論(speeches/opinions)". Since it carries a negative connotation here, it is translated as "denunciations".

Hence, "縱欲搪突羲、獻，誣罔鍾、張, 安能掩當年之目，杜將來之口？" should be interpreted in vernacular Chinese as:

> 這些人縱使愛好搪突地[自稱所習]盡依羲之獻之 ， 又或誣罔地[自謂所摹]確乃鍾繇張芝 ，卻如何能夠掩蓋當時人們[雪亮]的眼睛 ，杜絕將來人們[負面]的批評呢？
>
> (interpreted by Kwok Kin Poon)

(223). 至有未悟淹留 –"淹留" is a special technical term in Chinese calligraphy that means "slowing one's brush and pushing it down amidst penning a rapid brushstroke". For further discussions, please see Leung Pai Wan's (梁披雲) 《中國書法大辭典》(廣東: 廣東人民出版社 ，1991, p.94).

(224). 偏追劍疾 – Almost all current interpretations have mistakenly taken the original cursive character "劍" here as "勁".

The original "劍" in "偏追劍疾" is:

The cursive script of "劍" is:

Source: 《中國書法大字典》.台北: 大通書局, 1973, p.113.

Note that the right hand side of is "刃", which is the radical (部首) "刀" not "力".

(225,226). 翻效遲重 – "翻" means "反而(instead)" here. "遲重" is a technical term in Chinese calligraphy that means "penning a brushstroke slowly while pushing the brush down". For further discussions, please see Leung Pai Wan's (梁披雲)《中國書法大辭典》(廣東: 廣東人民出版社，1991, p.96).

(227). The entire sentence of "至有未悟淹留，偏追劲疾；不能迅速，翻效遲重" should be interpreted in vernacular Chinese as:

> 至於有些人未曾領悟「淹留」，祇片面地處處追求舞劍似的
> 快疾；又或不能快速，反過來卻祇懂一味效法「遲重」。
> (interpreted by Kwok Kin Poon)

(228,229). 夫勁速者超逸之機 – "勁速" in Chinese calligraphy means "penning powerfully with rapid speeds" and can be considered as the opposite of "遲重" seen in Line 222. For further discussions, please see Leung Pai Wan's (梁披雲)《中國書法大辭典》(廣東: 廣東人民出版社，1991, p.96).

"機" is "原由(causes)" here.

"勁速者超逸之機" should therefore be interpreted in vernacular Chinese as:

> 勁速是書法超逸的由來。
> (interpreted by Kwok Kin Poon)

(230,231). 遲留者賞會之致 – "遲留" is "遲重(Slow and Heavy) and 淹留(Stay and Hold)". For details, please see footnote (223).

"賞會" here means "心賞神會 (heartfelt appreciation and spiritual comprehension)".

As such, "遲留者賞會之致" should be interpreted in vernacular Chinese as:

遲留則帶來心賞神會的情趣。
(interpreted by Kwok Kin Poon)

Note "致" here is "情趣(disposition)" not "cause" or "leads to". Therefore, the two interpretations of "遲留者賞會之致" below are erroneous:

"deliberate lingering leads to perfect appreciation and comprehension." (Chang and Frankel:13)

"tardiness and pause lead to the appreciation and comprehension." (De Laurentis:58)

Such interpretations directly contradict Line 225, further illustrating their absurdities. Penning with just "淹留(Stay and Hold)" is far from ideal and was certainly not cherished by Sun Guoting.

(232). 將反其速 - "速" here refers to "速度(speed)" and so includes various speeds of slow and fast. Sun Guoting here contended that, to achieve a higher level in penning calligraphy, one should not pen with a constant speed but with variables speeds within a brushstroke; Lines 224 to 226 further lend support to this argument.

Hence, the proper vernacular Chinese interpretation of "將反其速" should be:

應當倒轉行筆的速度。(每一運筆 , 快速時須有少部份慢 , 慢速時須有少部份快 。 亦即要有變化 , 切莫同一速度 。)
(interpreted by Kwok Kin Poon)

Therefore, the following English interpretations of "將反 其速" are wholly incorrect:

"If you procced from lingering to speed" (Chang and Frankel: 13).

"Opposing swiftness" (De Laurentis: 58).

(233,234). 行臻會美之方 – In this context, "行" is "可以(can/ able to)", whereas "方" is "境(realm)".

(235). 專溺於遲 – "遲(Slow)" here refers to "遲重(Slow and Heavy)". For details, please see footnote (225,226).

(236). 因遲就遲 – "就" is "依從(go along)" in this context.

(237). 詎名賞會 – "名" here is "成(accomplish/bring about)".

(238). The proper vernacular Chinese interpretation of "能 速不速，所謂淹留；因遲就遲，詎名賞會" should be:

[一筆之中]，在能夠快疾的地方卻保留少部份慢，這就是所說 的「淹留」；[一畫之內]，因為遲慢而一味遷就遲慢，哪又怎 能成為令人心賞神會的[書法]呢？
(interpreted by Kwok Kin Poon)

(239). 心閑手敏 – Sun Guoting here indicated the necessity of a leisurely and tranquil mind (to facilitate penning slowly) as well as agile hands (to facilitate penning swiftly) in order to master "遲重(Slow and Heavy)", "淹留(Stay and Hold)", and "勁速(Strong and Swift)" all at the same time.

(240). 務存骨氣 – "骨氣" here refers to "瘦硬(brushstrokes that are sturdy and thin with power)" and also to structural framework of a character. This term is related to "Bones

122

(骨)" seen in Line 214. For further details on "Bones(骨)", please see footnote (209,210).

(241,242). 而遒潤加之 – "遒" here means "韌勁(tough and elastic with vigor)". "遒" is related to "筋(Tendons)" seen in Line 214. For further details on "筋(Tendons)", please see footnote (209,210).

"潤" means "豐潤(fullness)" and is related to the Chinese calligraphy term "Flesh(肉)", which refers to "brushstrokes that are thick and full(筆畫豐滿有致)". For further discussion on "Flesh(肉)", please see Leung Pai Wan's (梁披雲)《中國書法大辭典》(廣東: 廣東人民出版社 , 1991, p.98). "潤" is certainly not "moisture" as suggested by De Laurentis (De Laurentis: 58).

(243). 凌霜雪而彌勁 – "凌" here means "經歷(experience)".

(244). 如其骨力偏多 – "骨力" is equivalent to "骨氣" in Line 228.

(245). 遒麗蓋少 – "遒" means "韌勁(tough and elastic with vigor)" and refers to "筋(Tendons)" in Line 214.

"麗" means "elegance and prettiness" and refers to the Chinese calligraphy term "肉(Flesh)". For further details, please see footnote (241,242).

(246). 則若枯槎架險 – "枯槎" means "枝杈(twigs)", "架" means "搭建(construct)", "險" means "險要(a place where it is hazardous)". "枯槎架險" is used as a metaphor for brushstrokes that are thin, sturdy, crude and unrefined.

(247). 巨石當路- The entire phrase means "a large boulder blocking an important path", which is used here as a meta-

phor for brushstrokes that have no flow or continuity.

(248). 雖妍媚云闕 – "妍媚" means "prettiness and elegance" and is equivalent to Line 228's "潤" and Line 231's "麗", both of which refer to the Chinese calligraphy term "肉 (Flesh)". For further details, please see footnote (241,242).

(249,250). 譬夫芳林落蕊– "芳林" means "芬芳的花林(fragrant flowery forest)", whereas "落蕊" means "落花(fallen flowers)". "蕊" is "蘂"; see *Kangxi Dictionary* (《康熙字典》).

(251). 空照灼而無依 – "照灼" means "明豔(brilliant and glamorous)".

(252). 蘭沼漂蓱 – "蘭" here refers to the herbal plant "澤蘭(Eupatorium)", "蓱" is "萍" which refers to "浮萍(duckweed)".

(253). 是知偏工易就 – "偏" here means "不盡, 一部分(incomplete/partial)".

(254). 而變成多體 – "體" here means "shapes and forms of characters" written by some calligraphy learners. This "體" should be distinguished with "體" in Lines 177 and 206, which refers to "字體(fonts)". Furthermore, it is not "書體 (scripts)" nor "styles" as suggested by De Laurentis (De Laurentis:58).

(255,256). 莫不隨其性欲，便以為姿 - "性欲" means "one's personality as well as one's own preferences" in this context, "便" means "就(then)", and "姿" means "美貌(beauty)". Note "莫不隨其性欲，便以為姿" merely applies to some learners in this context, not all calligraphers; subsequent sentences (Lines 237 to 241) narrate their shortcomings. This sen-

tences certainly does not apply to "Every person"(Chang and Frankel:13) or "Everyone"(De Laurentis:58).

(257). 倥偬不遒 – "倥偬" means "堅直(sturdy)"and refers to "Bones(骨)" in Line 214.

(258,259). 剛很者又掘強無潤 – "剛很" is "剛愎(head-strong)". "掘強" is "rigid and sturdy" which relates to "Bones(骨)" in Line 214. "潤" is the same as Line 228's "潤", which refers to "Flesh(肉)". For further details, please see footnote (241,242).

(260). 矜斂者弊於拘束 – "矜斂" here means "謹慎內斂(cautious and self-reserved)".

(261). 脫易者失於規矩 – "脫易" means "輕率簡慢(reckless and negligent)".

(262). 躁勇者過於剽迫 – "剽迫" is "輕疾", and "輕疾" means "輕佻躁急(frivolous and impetuous)". "剽迫" is not "bounce" as suggested by De Laurentis (De Laurentis:59).

(263,264). 狐疑者溺於滯澀 – "狐疑" means "狐性多疑 (overly skeptical and sensitive)", whereas "滯澀" means "呆滯(sluggish without vitality)".

(265,266,267). 遲重者終於蹇鈍– "遲重" here means "不敏捷(dull-witted)" and should be distinguished from the "遲重" in Line 222. "終" in this context should be "常(often/frequently)", while "蹇鈍" means "遲鈍(Tardiness)". "遲重" is not "slow and heavy" as suggested by De Laurentis (De Laurentis:59).

(268,269). 輕瑣者染於俗吏 - Here, "輕" means "輕率(flippant)", "瑣" means "卑微(feeble)", and "俗吏" means "才智平庸的官吏(commonplace government officials/clerks)". The term "俗吏" carries a negative connotation of a person who is "矯飾外貌，似是而非(pretentious and makes specious arguments)" (see *Book of the Later Han, Volume 3, Annals of Emperor Suzong Xiaozhang*, 范曄《後漢書》卷三章帝紀, 香港:中華書局，1971，p.148).

(270,271). 斯皆獨行之士, 偏翫所乖 - "獨行" means "固執己意以行事(stubbornly acting only in accordance to one's prejudices)".

In this context, "偏" means "不盡, 一部分(incomplete/partial)" and is the same "偏" in Line 235, "翫" means "鬆懈、輕忽地學習 (practice the art superficially and negligently)", while "乖" means "差錯(flaw)".

Hence, "斯皆獨行之士, 偏翫所乖" is not "These are all literati who act arbitrarily, and unilaterally practice what is contrary to reason" as proposed by De Laurentis (De Laurentis:59). As well, "偏翫所乖" is certainly not "give in to their individual defects"(Chang and Frankel:13).

(272). Extracted from the *Book of Changes-Treatise on The Thwan I -Bi* (《易經• 彖辭上• 賁》). English translation presented here is made by James Legge in *Sacred Books of the East*.

(273). 近取諸身 – This phrase is from the *Book of Changes-The Great Treatise II* (《易經•繫辭下》) and should be interpreted as "drawing from or looking upon one's inner self/sensory faculties" as suggested by the original text and James Legge's interpretation:

近取諸身，遠取諸物

Near at hand, in his own person, he found things for consideration, and the same at a distance, in things in general.
-translated by James Legge in *Sacred Books of the East.*

疏曰: 正義曰, 近取諸身者, 若耳目鼻口之屬是也。

Explanatory note by Kong Yingda (孔穎達) : "近取諸身" refers to one's ears, eyes, nose, mouth, and the likes (ones's sensory faculties).

(interpreted by KS Vincent Poon)

Source: 王弼注、 孔穎達疏《周易注疏》,卷八「繫辭下」,
p.3a. 上海: 中華書局據阮刻本校刊, 1936.

"況書之為妙, 近取諸身" is certainly not "All the more, the making of the prodigy of calligraphy closely derives from one's person" as suggested by De Laurentis (De Laurentis:59).

(274). 假令運用未周, 尚虧工於祕奧 – This phrase is incorrectly translated by Chang and Frankel as "If your method is not perfect, you will miss its ultimate secret" (Chang and Frankel:14).

(275). 而波瀾之際 – "而" here means "然而(yet/but)" and "波瀾" is "起伏變化的思潮(dynamic emotions and thoughts)" as in Meng Jiao's *Ode to Heroic Ladies* (孟郊《列女操》):

波瀾誓不起 ，妾心井中水。
<u>Her heart</u> shall be composed and still like the waters of a deep well. - translated by Betty Tseng.

"際" is "中間/裏邊(in the middle/within)".

(276,277,278). 已濬發於靈臺 – In this context, "已" is "have already", "濬發" is "從深處發出(from the very deep/bottom

of)" and "靈臺" refers to "心(heart and mind)".

(279,280,281,282) 必能傍通點畫之情, 博究始終之理, 鎔鑄蟲篆, 陶均草隸 – "始終之理" is "the principles behind the evolution of the art", "鎔鑄" here should be interpreted as "digest and assimilate", "蟲" refers to the ancient "鳥蟲書 (worm script)", and "陶均" is "陶冶/造就(cultivate/accomplish)". Note further "隸" is "今隸", which is "楷書 (standard script)".

Here, drawing references from the *Book of Changes* (Line 242-243), Sun Guoting contended that even though if one is not too adept in calligraphy (Line 244), one can still eventually grasp the principles of the art, given one is able to express oneself genuinely (Line 245).

Hence, the two following interpretations of "必能傍通點畫之情, 博究始終之理, 鎔鑄蟲篆, 陶均草隸" are utterly ridiculous:

> "You must understand the use of dots and lines and make a broad study of historical developments of characters, absorb chong zhuan, and combine cao and li." (Chang and Frankel: 14)

> "It is necessary to be capable to extensively understand the temperament of brushstrokes, and to broadly investigate the principles [of using the brush] from the beginning to the end [of the execution]. One should the melt the worm and zhuan scripts, paste together the cursive and the standard [in his calligraphy]." (De Laurentis: 59)

One common fatal error in the interpretations above is taking "陶均草隸" as "combine cao and li" or "paste together the cursive and the standard". Sun Guoting had never encouraged anyone to combine scripts in their calligraphy.

(283). 體五材之並用 - "五材" refers to the "Five elements" of "金(Gold/Metal), 木(Wood), 水(Water), 火(Fire), 土 (Earth)".

(284). 象八音之迭起 – "象" here is "好像(as if)".

(285,286). 留不常遲, 遣不恆疾 – "留" is the same "留 (Hold)" in Lines 222 and 223, whereas"遲" is also the same "遲(Slow)" in Lines 222 and 223. For details on these two terms, please see footnotes (223) and (225,226).

(287). 將濃遂枯 – In this context, "將" means "行/施行(to accomplish/execute)", while "遂" means "順從(comply)".
　　"將濃遂枯" is hence not "when the ink is too thick, it leads to dryness" as suggested by Chang and Frankel (Chang and Frankel:13).

(288,289). 泯規矩於方圓 – "規" here refers to "畫圓的工 具,今叫圓規(an instrument that is used draw circles, now known as a pair of compasses)", while "矩" is "畫直角或 方形用的曲尺(a ruler that is used to draw right angles or squares)".

(290). 遁鈎繩之曲直 – "鈎" here is "曲尺/木匠用來畫圓的工 具(a curved rule/a divided calipers in carpentry)".

(291,292). 乍顯乍晦– "乍" means "忽(suddenly)" and "顯" means "公開(open)" in this context.

(293,294). 若行若藏 – "行" here means "往(going to-wards)", while "藏" means "隱匿 (hiding behind)".

(295). 合情調於紙上 – "合" here means "聚合(amass)". It is not "harmonize" (Chang and Frankel:14) nor

"amalgamate"(De Laurentis:60).

(296,297). 無間心手, 忘懷楷則 – "無間" means "無間斷/不分 (seamlessly without any separation)" and "忘懷" means "不 介意/不放在心上(not minding/not care about)".

(298,299). 譬夫絳樹青琴– "絳樹" originally refers to a legendary celestial tree (仙樹) but is often used as a metaphor for a beautiful lady (美女). "青琴" originally refers to the name of a goddess but is often used as a metaphor for a pretty woman.

(300,301). 隨珠和璧 – "隨珠" is "隨侯珠(The Rock Globe of Marquess Sui)", which was a national treasure of Sui (隨 國) during the Spring and Autumn period (春秋時期). This treasure is not a "pearl" (De Laurentis: 60) but is said to be an exquisite globular fluorescent rock (夜明珠).

"和璧" refers to the renowned "和氏璧 (He's Jade Disc)", which was regarded as a prized possession by many states and dynasties throughout Chinese history.

(302). 異質同妍 – "妍" is "prettiness", not "valuable" as translated by Chang and Frankel (Chang and Frankel:14).

(303). 竟慙眞體 –"竟" here means "終於(eventually)" and "體" is "本性/本質(true nature)". Sun Guoting contended here that there is no need to rigidly follow rules and exemplars in writing calligraphy as it will eventually lead to obscuring and misrepresenting one's true nature. Hence, "竟慙眞體" is certainly not "debasing the originals" (Chang and Frankel:14).

The proper vernacular Chinese interpretation of "何必刻 鶴圖龍, 竟慙眞體" should be:

何必[死板地]雕鶴繪龍, 終有愧於[自己的]真實本性。
(interpreted by Kwok Kin Poon)

(304,305). 猶悋筌蹄 – "悋" is "吝", which means "恨惜(hold dear)". "筌" is "捕魚的竹器(an instrument made with bamboo that is used to catch fish)" and "蹄" is "攔兔的器具(an instrument that is used to capture and intercept rabbits)".

(306). 聞夫家有南威之容 – "南威" refers to "春秋時代晉國的美女 (a beautiful lady living in the Jin state during the Spring and Autumn Period)".

(307,308). 有龍泉之利，然後議於斷割 – "龍泉" is the alternative name for the legendary sword "龍淵(Long Yuan)".
　　"斷割" here refers to extremely sharp sword blades that can cut through materials leaving all cut ends to be smooth, flushed, and without any rough edges (齊口截斷) as elaborated in 王念孫《廣雅疏證》:

> 斷者，說文斷截也。斷與剒聲近而義同，今人狀物之齊曰斬齊，是其義也。
> Source: 王念孫，《廣雅疏證》，卷四上，釋詁，p.442. 上海: 商務印書館，1939.

(309). Line 262 was derived from Cao Zhi's (曹植) *A Letter to Yang Dezu* (《與楊德祖書》):

> 蓋有南威之容，乃可以論其淑媛；有龍泉之利，乃可以議其斷割。

(310). 實累樞機 – "樞機" in this context means "言行(words and moral conduct)". This is supported by two classical Chinese text sources:

I. In *Annotations and Explanatory Notes on the Book of Changes* (《周易注疏》):

言行，君子之樞機。樞機之發，榮辱之主也。
Words and moral conduct are a gentleman's 樞機(Shu Ji). When 樞機(Shu Ji) emanates, it becomes the master of one's pride and shame.
(translated by KS Vincent Poon)

Annotation by Wang Bi (王弼注):

樞機，制動之主。
樞機(Shu Ji) is the master of one's action.
(translated by KS Vincent Poon)

Further explanatory notes by Kong Yingda (孔穎達疏):

樞謂户樞(門的轉軸),機謂弩牙(弩機鉤弦的部件, 控制發射)。…
猶言行之動, 從身而發, 以及於物, 或是或非也。
"樞 (Shu)" is the "hinge" of a door and "機 (Ji)" is the "hook" of a crossbow… Together they are like the actions of one's words and moral conduct, emanating from oneself, affecting others, and can be right or wrong.
(translated by KS Vincent Poon)

Source: 王弼注、 孔穎達疏《周易注疏》,卷七「繫辭上」, p.10b. 上海: 中華書局據阮刻本校刊, 1936.

II. In the *Records of the Three Kingdoms* (《三國志》), "樞機不慎(not careful with words and conduct)" and "樞機敏捷 (respond quickly with words and conduct)" can be seen to describe one's words and actions. See 陳壽 《三國志》蜀志卷十二來敏傳, p.6a & 吳志卷八薛綜傳, p.6b (臺北: 中華書局,1968).

Therefore, the proper vernacular Chinese interpretation of "語過其分，實累樞機" is:

說話超出自己的本分, 實在有損[關乎個人品格榮辱的]言行。
(interpreted by Kwok Kin Poon)

As such "語過其分，實累樞機" is not "These two sayings exaggerate, yet they concern a pivotal matter" (Chang and Frankel:15) nor "Theses sentences are yet excessive, but they actually touch a crucial point" (De Laurentis:60).

(311,312). 尤喻所聞 – "尤" here means "喜愛(like to)", while "喻" means "告知(tell)".

(313). 輕致陵誚 – In this context, "輕" means "輕率(casually without much consideration)", "致" means "給予(give)", and "陵誚" is "欺侮嘲諷(offensive ridicules)".

(314,315). 余乃假之以緗縹 – "假" here means "美(to beautify/embellish)" as indicated in *Kangxi dictionary* (《康熙字典》).

"緗縹" here refers to "淺青或淺黃色的絲帛(light yellow or light green silk cloths)", which is used as a metaphor for a box that is used to retain a set of books or even as a metaphor for text scrolls (書卷).

Therefore, the proper vernacular interpretation for "余乃假之以緗縹" should be:

> 於是我把它放在絲帛做的書匣(書囊)裏面, 好看似十分貴重。
> (interpreted by Kwok Kin Poon)

(316,317). 競賞豪末之奇，罕議峯端之失 – "豪末" means "the tip of a brush", while "峯端" means "the sharp peak of a pen"; both are used here as metaphors for the brush used in writing Chinese calligraphy. "豪末" here is certainly not "the smallest detail" as suggested by Chang and Frankel (Chang and Frankel: 15).

(318). 惠侯之好偽 – This phrase refers to a story of Marquess Hui (惠侯) who cherished Wang Xizhi's calligraphy

yet often collected forgeries of Wang's works:

新渝惠侯雅所愛重，懸金招買，不計貴賤。而輕薄之徒，銳意
摹學，以茅屋漏汁染變紙色，加以勞辱，使類久書。真偽相
糅，莫之能別。故惠侯所蓄，多有非真。
Source: Yu He's (虞龢) *On Calligraphy* (《論書表》) . See 《
歷代書法論文選》. 上海: 上海書畫出版社, 1979, p.50.

(319). 葉公之懼真 – This phrase relates to a narrative in
Xinxu - Miscellaneous affairs V (《新序• 雜事五》) that de-
scribed a person, Mr. Yip, who was obsessed with imitated
lifeless dragons but feared the real lively ones:

葉公子高好龍，鉤以寫龍，鑿以寫龍，屋室雕文以寫龍，於是
夫龍聞而下之，窺頭於牖，拖尾於堂，葉公見之，棄而還走，
失其魂魄，五色無主，是葉公非好龍也，好夫似龍而非龍者
也。
Source: 劉向《新序》卷五雜事. 上海:商務印書館, 1939, p.89.

(320,321). 是知伯子之息流波 – "伯" refers to "伯牙 (Bo
Ya)", "子" means "Master", "息" means "停止(stop)", and
"流波" refers to Bo Ya's music that was as beautiful as
high mountains and running rivers (高山流水). This phrase
refers to the story of the legendary musician Bo Ya who
vowed not to play music ever again after the death of his
audience Zhong Zi Qi (鍾子期), who could truly appreci-
ate and comprehend his music . For details, please see
footnote (153).

(322). 蔡邕不謬賞 – This phrase alludes to a story docu-
mented in the *Book of Later Han* (《後漢書》) regarding
Cai Yong (蔡邕); by simply listening to the sound of burning
of a particular type of Paulownia (桐) wood, Cai Yong was
able to conclude that it was an excellent material for mak-
ing the renowned musical instrument Jiao Wei Qin (焦尾
琴):

吳人有燒桐以爨者，邕聞火烈之聲，知其良木，因請而裁為琴，果有美音，而其尾猶焦，故時人名曰「焦尾琴」焉。
Source: 范曄《後漢書》卷六十下蔡邕列傳. 香港:中華書局，1971，p.2004.

(323). 孫陽不妄顧者 – This phrase alludes to a story documented in *Strategies of the Warring States* (《戰國策》) regarding Sun Yang (孫陽) who is also known as Bo Le (伯樂). The story narrated Sun Yang's (Bo Le) extraordinary ability to comprehend and empathize with horses by observing and listening to them:

夫驥之齒至矣，服鹽車而上太行。蹄申膝折，尾湛胕潰，漉汁灑地，白汗交流，中阪遷延，負轅不能上。伯樂遭之，下車攀而哭之，解紵衣以冪之。驥於是俛而噴，仰而鳴，聲達於天，若出金石聲者，何也？彼見伯樂之知己也。
Source: 臧勵龢選註《戰國策》楚, 汗明見春申君. 上海:商務印書館, 1933，pp.158-159.

(324). 奇音在爨 – "奇音" means "wonderful sounds", whereas "爨" is "燒(burn)".
　　"奇音在爨" alludes to Cai Yong's (蔡邕) extraordinary ability to discern the quality of a piece of wood just by listening to the sound that it makes while it is burning. For further details, please see footnote (322).

(325). 逸足伏櫪 – "逸足" literally means "speedy feet", which serves a metaphor for a speedy stallion. "伏櫪" is "馬伏在槽上(a horse lying inside a stable)".
　　"逸足伏櫪" alludes to Sun Yang's (孫陽) brilliance in judging horses by observing and listening to them. For details, please see footnote (323).

(326,327). 良樂未可尚也 – Here, "良" is "王良(Wang Liang)"

who was renowned for his excellent command of horses while riding on chariots, whereas "樂" refers to "伯樂/孫陽 (Bo Le/Sun Yang)" who was famous for evaluating horses. These are best supported by a passage in the *Book of Han -Afterword and Family History I* (《漢書•敘傳上》):

> 良樂軼能於相馭，烏獲抗力於千鈞。
> Liang and Le were outstanding in commanding and evaluating horses, Wu Huo (a renowned warrior during the Waring States period) could lift one thousand jun (one jun is thirty catty).
> (translated by KS Vincent Poon)
>
> Annotation by Yan Shigu (顏師古注) :
>
> 良，王良也。樂，伯樂也。
> Liang (良), was Wang Liang (王良); Le (樂), was Bo Le (伯樂).
> (translated by KS Vincent Poon)
>
> Source: 班固 《漢書》卷一百上「敘傳上」. 香港: 中華書局,1970, pp.4231&4233.

Chang and Frankel (Chang and Frankel:15) as well as De Laurentis (De Laurentis:61) had obliviously misinterpreted "良樂" as merely "Bo Le" and completely missed "Wang Liang" in the term.

(328). 老姥遇題扇, 初怨而後請– This alludes to a story in the *Book of Jin* (《晉書》) regarding an encounter between Wang Xizhi and an elderly woman who was selling bamboo fans:

> (王羲之)又嘗在蕺山見一老姥，持六角竹扇賣之。羲之書其扇，各為五字。姥初有慍色。因謂姥曰：「但言是王右軍書，以求百錢邪。」姥如其言，人競買之。他日，姥又持扇來，羲之笑而不答。

Source: 房玄齡《晉書》卷八十王羲之傳. 北京:中華書
局，1974，p.2100.

The synopsis of the story is as follows: Wang once intended to help an elderly lady to sell her fans by scribing his calligraphy on them. The lady initially was displeased (perhaps she thought that he ruined her fans), but the fans later became extremely popular and were all sold at a high price. Eventually, she went back to Wang and invited him to write more for her.

(329,330). 門生獲書機，父削而子懊– "機" is "几案(long desk)". This alludes to a story in the *Book of Jin* (《晉書》) regarding Wang Xizhi and one of his disciples:

> (王羲之)嘗詣門生家，見棐几滑淨，因書之，真草相半。後為
> 其父誤刮去之，門生驚懊者累日。
> Source: 房玄齡《晉書》卷八十王羲之傳. 北京:中華書
> 局，1974，p.2100.

The synopsis of the story is as follows: Wang once paid a visit to the home of one of his disciples. During his visit, Wang found a smooth clean desk and scribed his standard and cursive scripts on it. Later, the disciple's father scrapped them off (perhaps thinking it was dirt), leaving the disciple shocked and remorseful for many days.

Note "懊" here means "驚詫懊悔(shocked and remorseful)".

(331). 彼不知也，曷足怪乎 – "彼" here means "那些(those)", 曷 means "何/什麼(why)", and "怪" means "埋怨/責備(blame/criticize)".

(332). Extracted from *Zhuangzi - Inner Chapters - Enjoy-*

ment in Untroubled Ease (《莊子 • 內篇 • 逍遙遊》). English translation is made by James Legge in *The Texts of Taoism*.

(333). Extracted from Laozi (《老子》). English translation is made by James Legge in *The Texts of Taoism*.

(334). 豈可執冰而咎夏蟲哉 – This phrase alludes to an assertion found in *Zhuangzi - Outer Chapters - The Floods of Autumn* (《莊子 • 外篇 • 秋水》):

> 夏蟲不可以語於冰者，篤於時也。
> An insect of the summer cannot be talked with about ice - it knows nothing beyond its own season. - translated by James Legge in *The Texts of Taoism*.

(335). This line further supports that Sun Guoting's narration in the *Shu Pu* here was focused on calligraphy on or beyond the late Han dynasty, consistent with footnote (1). Together with Lines 126 to 137, it is evident that the *Shu Pu* was restricted to outlining and discussing calligraphy that was written between the periods of the late Han and late Southern dynasties (approx. 1st to 6th Century AD).

(336). 了不殊於既往 – "了" means "完全(completely)" in this context.

(337). 或苟興新說 – "苟" here means "苟且/隨便(casually)". Chang and Frankel had inattentively left out this keyword "苟(casually)" and interpreted this sentence as "some develop new theories" (Chang and Frankel:16), which significantly differs from the original meaning of Line 284.

(338). 竟無益於將來 – "竟" here means "終究(ultimately)".

(339). 徒使繁者彌繁 – "徒" here means "祇(only)".

(340). 第其工用 – "第" is a verb here and so it should be interpreted as "品評(judging)". "其" refers to *Shu Pu* itself, whereas "工用" here is "功用(usage and application)". Therefore, the proper vernacular Chinese interpretation of "第其工用，名曰書譜" should be:

> 從它的功用來說, 叫做書譜。
> (interpreted by Kwok Kin Poon)

Hence, "第其工用" is not "arranged it for practical use" (Chang and Frankel:16) nor "It orders in sequence the technique and the applications [of calligraphy]" (De Laurentis:62).

(341). 庶使一家後進 – "庶" means "希冀(hope/wish)" in this context. Note De Larentis had erroneously took "使一家後進" as "lead someone to the improvement" (De Laurentis:62).

(342). 緘祕之旨 – Here, "旨" means "主張(position/notion)". Note Chang and Frankel had incorrectly translated "緘祕之旨, 余無取焉" as "I have not included in it any mysterious secrets" (Chang and Frankel:16).

Bibliography

English

Chang Ch'ung-ho & Frankel Hans H., *Two Chinese Treatises on Calligraphy*. New Haven & London: Yale University Press, 1995.

De Laurentis, Pietro , *The Manual of Calligraphy by Sun Guoting of the Tang*. Napoli: Universita degli Studi di Napoli "L'Orientale", 2011.

Legge, James, *The Chinese Classics: with a Translation, Critical and Exegetical Notes, Prolegomena, and Copious Indexes, Volume 1, Confucian Analects, the Great Learning, and the Doctrine of the Mean*. Oxford: Clarendon Press ,1861.

Legge, James, *Sacred Books of the East, Volume 3, The Hsiâo king*, edited by Max Mueller. Oxford: Clarendon Press ,1879.

Legge, James, *Sacred Books of the East, Volume 3, The Shû king*, edited by Max Mueller. Oxford: Clarendon Press , 1879.

Legge, James, *Sacred Books of the East, The Texts of Taoism*, edited by Max Mueller. Oxford: Clarendon Press :1891.

Legge, James, *Sacred Books of the East, Volume 16, The Yî king*, edited by Max Mueller. Oxford: Clarendon Press :1891.

Poon, KS Vincent & Poon, Kwok Kin, *English Translation of Classical Chinese Calligraphy Masterpieces 英譯法書*. Toronto: The Senseis, 2019.

Chinese

上海書畫出版社,《歷代書法論文選》。上海: 上海書畫出版社, 1979。

王念孫,《廣雅疏證》。上海: 商務印書館 , 1939。

王弼注、 孔穎達疏,《周易注疏》。上海: 中華書局據阮刻本校刊, 1936。

王著編,《淳化閣帖》。天津: 天津市古籍書店,1986 。

司馬遷,《史記》。 香港: 廣智書局 , 出版年份缺。

朱熹,《四書集註》。香港: 太平書局, 1968。

李昉編,《太平御覽》。嘉慶十二年歙鮑氏校宋版。

佚名,《宣和書譜》。上海: 上海書畫出版社, 1984。

杜佑,《通典》。光緒丙申年四月浙江書局刊。

房玄齡,《晉書》。北京:中華書局, 1974。

范曄,《後漢書》。 香港:中華書局, 1971。

班固,《漢書》。 香港:中華書局, 1970。

高亨,《文字形義學概論》。香港: 邵華文化服務社, 翻印版, 出版年份缺。

馬永強,《書譜•書譜譯注》。鄭州市: 河南美術出版社, 1993。

馬國權,《書譜譯注》。 臺北: 明文書局, 1988。

唐蘭,《中國文字學》。上海: 開明書店, 1949 。

啟功,〈孫過庭書譜考〉。見《啟功叢稿》, 北京: 中華書局, 1999。

陳壽,《三國志》。 臺北: 中華書局, 1968。

郭慶藩,《莊子集釋》。北京: 中華書局, 1985。

臧勵龢選註,《戰國策》。上海:商務印書館, 1933。

劉文典,《淮南鴻烈集解》。上海:商務印書館, 1933。

潘國鍵, 《 孫過庭書譜白話對譯 》。 多倫多: 尚尚齋, 2019 。

劉向,《新序》。上海:商務印書館, 1939。

劉昫,《舊唐書》。 臺灣: 臺灣中華書局, 1971。

葛洪,《抱朴子》。上海: 商務印書館, 1936。

Dictionary

段玉裁,《說文解字注》。臺北: 藝文印書館, 1966。

梁披雲編 ,《中國書法大辭典》。廣東: 廣東人民出版社,1991。

《中國書法大字典》。台北: 大通書局, 1973 。

《康熙字典》。上海:上海書店, 1985。

Websites

《搜詞尋字》 (中央研究院)。words.sinica.edu.tw/sou/sou.html。

《異體字字典》(中華民國教育部)。http://dict2.variants.moe.edu.tw/main.htm。

《 潘國鍵宗哲書法講座 》 。http://poonkwokkin.com 。

《漢典》。www.zdic.net 。

《漢語網》 。www.chinesewords.org 。

PART THREE:

Modelling of *A Narrative on Calligraphy* by KS Vincent Poon

Modelling of *A Narrative on Calligraphy* by KS Vincent Poon